IMAGES OF AMERICA

WESTON

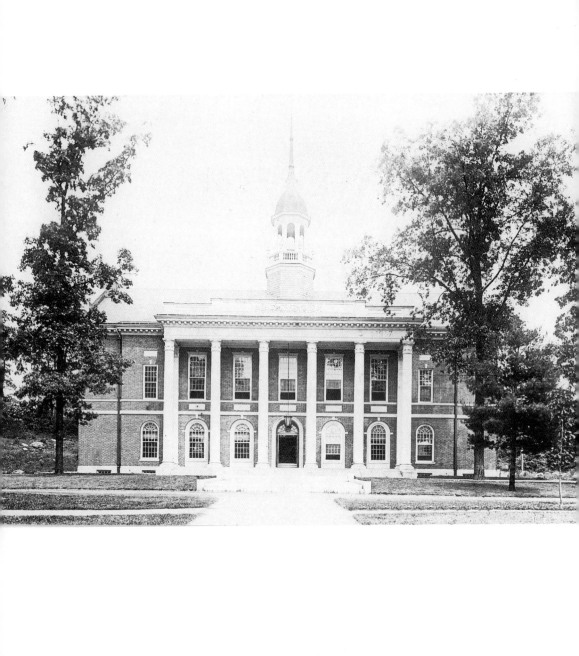

IMAGES OF AMERICA

WESTON

LEE MARSH

ARCADIA

Frontispiece: Town Hall, Weston, Massachusetts

First published 1999
Re-issued 2003

Published by Arcadia Publishing
an imprint of Tempus Publishing Inc.
Charleston SC, Chicago, Portsmouth NH,
San Francisco

Printed in Great Britain

Library of Congress Catalog Card Number: 2003107169

For all general information contact Arcadia Publishing at:
Telephone 843-853-2070
Fax 843-853-0044
E-mail sales@arcadiapublishing.com
For customer service and orders:
Toll-Free 1-888-313-2665

Visit us on the internet at http://www.arcadiapublishing.com

Contents

Acknowledgments

The collection of photographs from the archives of the Weston Historical Society provided most of the images in this book. The captions are based on articles in the Society's Bulletins and books written by several Weston residents. The Society, founded in 1963 under the leadership of Harold G. Travis, continues to research and record all aspects of town history. Weston has been fortunate in the historians who have preserved its story. The writings of Daniel Lamson, Brenton H. Dickson, Homer Lucas, and Dr. Vera Laska made it a pleasure to do the research for this book. I should like to recognize specifically Harold G. Travis, Donald G. Kennedy, and Dr. Vera Laska, the editors of the Bulletins who have written about many interesting events and personalities. Douglas Henderson shared his knowledge of the documents owned by the Weston Historical Society. George Amadon and Pamela Fox have devoted their expertise to identifying and preserving the Society's photographs. Without the efforts of these dedicated volunteers, this record of town history would not have been possible. Many thanks also to those who contributed their personal photographs and reminiscences: George Amadon, J. Kenneth Bennett, Grant Dowse, Cheryl Eisner, Marjorie Harnish, Emily Hutcheson, Anna Melone, Bob Pollock, Patty Melone Wright, Joseph P. Sheehan Jr., and Penny Theall.

Bibliography

Coburn, Philip F. *Growing Up in Weston*. Waltham, MA: Copigraph, Inc., 1981.

Dickson, Brenton H. *Once Upon a Pung*. Boston: Thomas Todd Company, 1963.

Dickson, Brenton H. and Homer C. Lucas. *One Town in the American Revolution*. Weston, MA: Weston Historical Society, 1976.

Dickson, Brenton H. *Random Recollections*. Weston, MA: Nobb Hill Press, Inc., 1977.

Lamson, Daniel S. *History of the Town of Weston,* Massachusetts 1630–1890. Boston: George H. Ellis Company, 1913.

Ripley, Emma F. Weston: *A Puritan Town*. Cambridge, MA: The Riverside Press, 1961.

Waltham Free Press Newspaper. Weston Public Library.

Weston Historical Society. *Bulletins*. 1964 to present.

Weston Town Reports.

Introduction

Weston is a small community situated 12 miles west of Boston, Massachusetts. The history of the town reflects many of the major events and changes in the history of the country. Puritan farmers first settled the westernmost land of Watertown in the late 1600s. Preferring to worship close to home, they built their own meetinghouse in 1698 and established a separate community from Watertown in 1713. While primarily a farming community until the end of the 19th century, Weston grew and prospered as mill owners and shopkeepers set up businesses in the town.

Weston played a role in the Revolutionary War. Two British spies stayed at the Golden Ball Tavern shortly before the Battles of Lexington and Concord, reporting to General Gage that Weston was a town to be avoided by British soldiers. General Henry Knox brought the cannon from Fort Ticonderoga through town on his way to Dorchester Heights, and young men served in the war.

Weston played a part in the Industrial Revolution, made possible by the three railroad lines built through the community. The village of Kendal Green, in the northeast corner of town, had its own general store, post office, and train station, a great convenience for nearby residents. There were several small industries in town, including the Hastings Organ Factory. This factory, owned by Frank Hastings, was one of the last attempts to establish a model industrial community under the guidance of an individual owner. The organ factory prospered, and the Boston newspapers reported the success of the community shared by the owner and the workers.

Weston, however, was in and out of the Industrial Revolution faster than any town in the United States. Many wealthy Boston businessmen recognized that Weston's landscapes, location, and low tax rates made the town an ideal choice for their new estates. The Boston papers described Weston as the "Lenox of the East" because of the many beautiful homes and gardens built in town by the turn of the century. The new residents took pride in joining the community and they contributed their expertise and money to improving the town.

Weston residents joined wholeheartedly in the spirit of the Progressive Era, making many improvements in the community through official town actions and volunteer societies. Many of the photographs and news items included in this book date from the period between 1900 and 1912, when the town was making choices that make Weston a desirable suburb today. The pace of social and industrial change was picking up in those years, and Weston faced many decisions that would affect the nature of the community for decades to come. Weston voters rejected incorporation into the city of Boston as well as proposals for street railways. They did support construction of a new library, provided for the poor and the ill, and began the process of centralizing the schools to improve the quality of instruction. The construction of the Town Green and Town Hall were major projects between 1912 and 1917. The town records reflect widespread support for Theodore Roosevelt's belief that "every man must devote a reasonable share of his time doing his duty in the political life of the community. No man has a right to shirk his political duties under whatever pleas of pleasure or business . . ." The many volunteers, past and present, who serve in town government and support local programs exemplify Roosevelt's ideal. In a community of fewer than 2,000 people, residents knew each other and were committed to the improvement of their town. When the town celebrated its bicentennial in 1913, there was much to be proud of. The historical pageant and parade were attended by more than 2,000 people.

Douglas Henderson recorded the following thoughts on the character of the town in 1988 at the time of its 275th anniversary:

> Weston as a community lives in its schools, its library, the Town Hall, the swimming pool, the village center businesses scaled to Weston's size, and its churches. Young people had, and still have, a special place in Weston. Witness the many groups organized around them. "Network" is a modern buzzword, but it had its embodiment for me in a woman who cared for those in distress and called on her many friends to give help, charitably and anonymously. On a larger scale, it was evident in the support of the community for its public servants: the teachers, police, firemen, highway and water department employees. The Depression, World War II, and population mobility and unrest have placed great strains on the social contract which permeated and informed Weston community life. We preserve the monuments of the past as an anchor to windward in troubled times. They also constitute the nucleus around which Weston build its special character, its social values.

Change is inevitable when a town is located in a major metropolitan area. Town population grew substantially in the 1950s and 1960s, following the construction of Route 128 and the Massachusetts Turnpike. Physicians, lawyers, professors, and businessmen appreciated the 15 minute drive into downtown Boston. In the 1960s, many townspeople took action for better race relations, world peace, and the environment, creating the Weston-Roxbury Pre-School, the Weston Coalition against Racism, Green Power Farm, and Land's Sake Farm. Today, the population exceeds 10,000, and prosperity has brought pressures for increased development.

As the town enters the 21st century, one may ask, "Will this experiment in building a strong community continue?" If past history is a guide, the answer will be "yes."

one

First Hundred Years

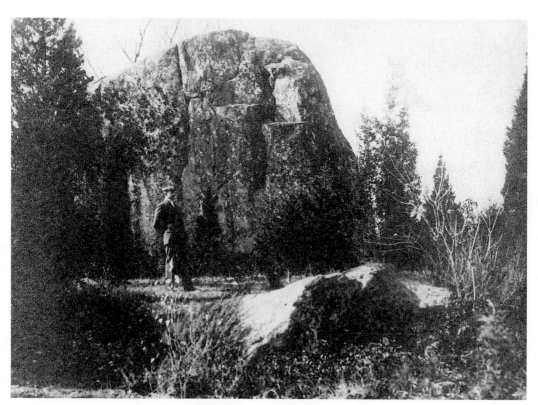

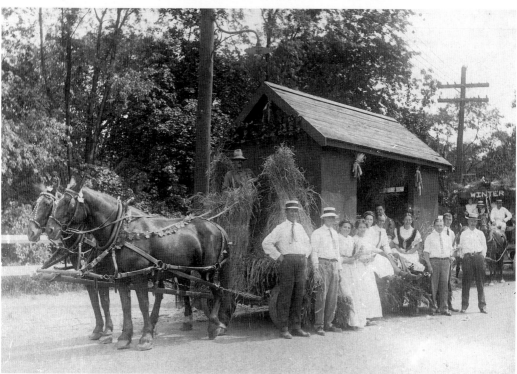

Above: Isaac Jones built the Golden Ball Tavern at 662 Boston Post Road in 1768. The tavern took its name from the tavern sign, a gilded wooden ball slightly larger than a football. Jones was a well-known Tory who served tea during the time Patriots were enforcing an embargo on all English tea. Although he claimed that he had bought the tea from the Dutch, he paid the price for serving tea on March 28, 1774, when Patriots, disguised as Native Americans, broke into the tavern, drank all the liquor, and destroyed the tea. He later swore an oath of loyalty to the Patriots and served as a contractor hauling goods for the Massachusetts Board of War. Shortly before this 1963 photo was taken, the tavern was purchased from the last descendant of the Jones family by Mr. and Mrs. Howard Gambrill Jr. The house had been owned by the Jones family for almost 200 years. The Golden Ball Tavern Trust has established a museum devoted to studying changes in architecture and domestic life from 1768 to the present.

Opposite, above: First identified as "The Farmers' Precinct" of Watertown, the 3-by-12-mile area, known as Weston today, was settled by Puritan farmers. The first allotment of land was recorded in Watertown in the 1630s. The glacial erratic by None Such Pond, shown here, is typical of some of the larger rocks. Farmers sought out the best land in the area for their farms.

Opposite, below: Solomon Johnson, one of the first residents, agreed to herd the "dry cattle" of Watertown in Weston in 1651. The first grain mill was built in 1679. This harvest float from the 1913 bicentennial celebration reflects the success of Weston farmers. In both summer and winter, they traveled weekly with their families to the Watertown meetinghouse for services. Eventually, this trip led them to request the right to conduct their own services.

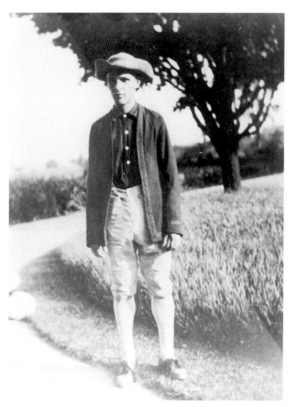

Young men, seeking farms a few miles from the markets for many of their products, moved from Boston and Watertown to Weston. Dressed for the bicentennial of the town in 1913, Arthur Moore represented the sturdy yeoman farmers who raised cattle, planted apple trees, and developed side occupations to provide incomes during the long months of winter. Eldest sons generally inherited the family farm, requiring their younger brothers to seek their fortunes elsewhere.

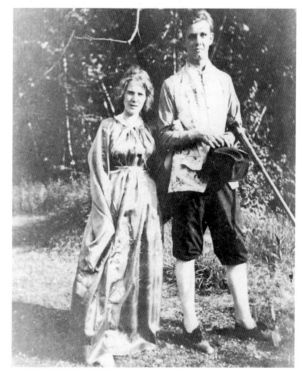

Right: Once settled in Weston, families stayed for generations. William and Mary Smith had seven children between 1715 and 1730. Their son Josiah built the tavern in the center of the town. The eighth generation of the family is represented by Edwin Lincoln Smith, a current resident. This couple represented young families in 1913.

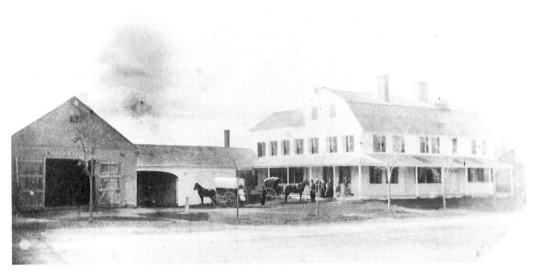

Above: The Josiah Smith Tavern is a well-known landmark in the center of Weston. Smith was a typical entrepreneur of his time, operating a popular tavern while farming substantial acreage behind the buildings. The 1771 tax lists show Smith owned one horse, six oxen, eight cows, and four swine. He farmed 12 acres of tilled land and 40 acres of pasture land. He produced more than 30 barrels of cider, much of which would have been served in the tavern. Smith still had time to take an active role in politics, and his tavern became known as a place where it was safe for Patriots to vent their feelings. Smith also owned two slaves, who probably did much of the work for the tavern. There were 16 slaves in Weston until 1781, when the Superior Court of Judicature of Massachusetts confirmed a jury verdict that no one could be held in slavery in the state because slavery violated the state Bill of Rights that "all men are born free and equal." The tavern is now the headquarters of the Weston Historical Society.

Below: The Thomas Allen house, built about 1696, is the oldest house in town still standing. The original stone walls in the front of the house mark the original north/south road through town. Located at the corner of Wellesley and Chestnut Streets, the house is typical of farmhouses in the early years of settlement. The house exterior and interior have undergone extensive restoration in the last 40 years. This photograph was taken c. 1895.

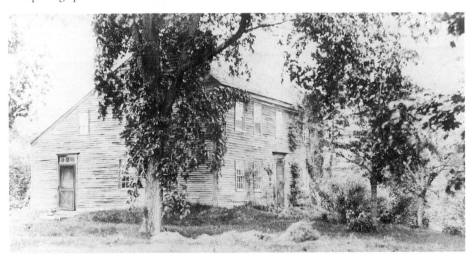

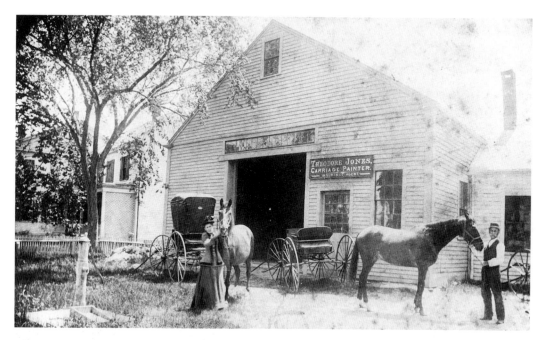

Above: The barn of the Josiah Smith Tavern, shown here before 1900, was a busy place during the first hundred years of the town. Stagecoaches from Boston heading to New York arrived with hungry visitors, who stopped for early breakfasts. The coaches left Boston at 3 a.m. and arrived in Weston a few hours later. The tavern offered meals and lodging for passengers and fresh horses for the coaches.

Below: Samuel Phillips Savage, a judge and the moderator of the Old South Meeting House gathering that preceded the Boston Tea Party, built this house on North Avenue before the Revolution. He farmed 16 acres in Weston and operated a gristmill while serving as president of the Board of War, which provided supplies to the Patriot Army. The house, seen here in 1895, was extensively remodeled around 1880.

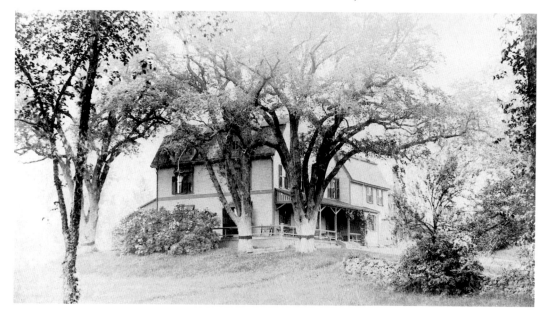

Right: Dressed for the town bicentennial (1713–1913), these young men represent Patriot soldiers. In November 1774, Elisha Jones, a prominent Tory lawyer and businessman, persuaded 55 Weston men to enlist in his company to take military training to defend the king, but 40 signed retractions two months later. Jones himself fled to Boston late in 1774, leaving behind extensive property to be confiscated by the Patriots. He died in Boston in February 1776.

Below: Most of the 180 Weston men sent to fight in the Revolution left on April 19, 1775, when 103 officers headed toward Concord over Lamson's Hill before learning that the British were in retreat. The train band changed course and headed toward Lexington, where they struck at the retreating British and then followed them into Charlestown. The re-enactment of the Weston Light Infantry is shown here in a photo from the bicentennial.

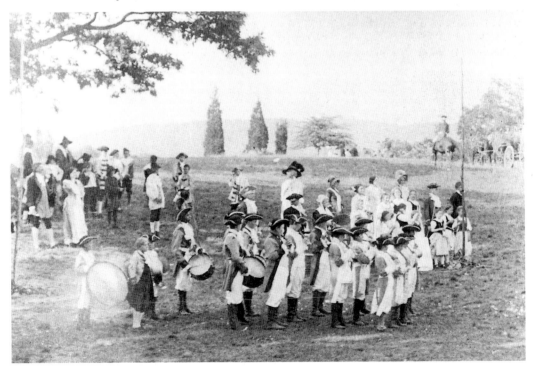

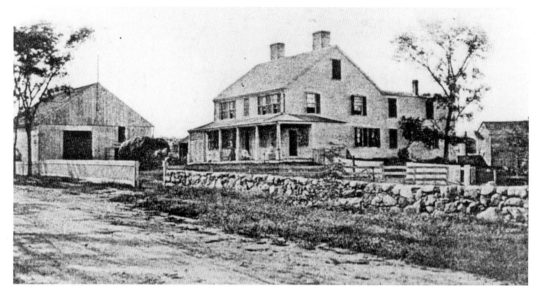

John Flagg entertained George Washington at his tavern, located at the western intersection of Boston Post Road and the By-Pass, on October 23, 1789. Washington received ovations when he met the townspeople the next day, and Hannah Gowen, then a child, never forgot that she had been kissed by the President of the United States. Washington left town, escorted by the Watertown Cavalry Company, to dine with Governor Hancock in Boston.

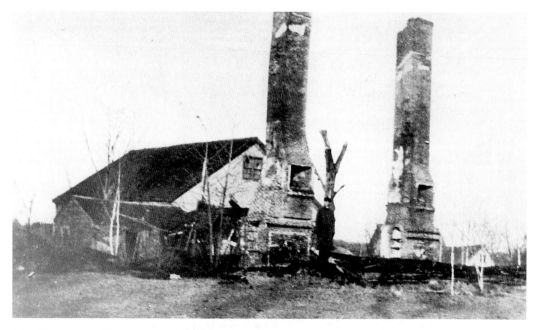

John Flagg operated his tavern for more than 40 years until 1812. Fire destroyed the building on November 6, 1902. Few of the early taverns remain. Some were destroyed by fire, while others were torn down to make way for modern buildings. Many townspeople living on the majorroads operated taverns for meals and lodging for short periods of time to supplement their farming income.

two

Community

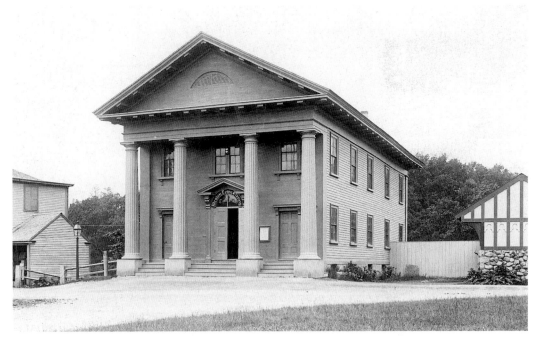

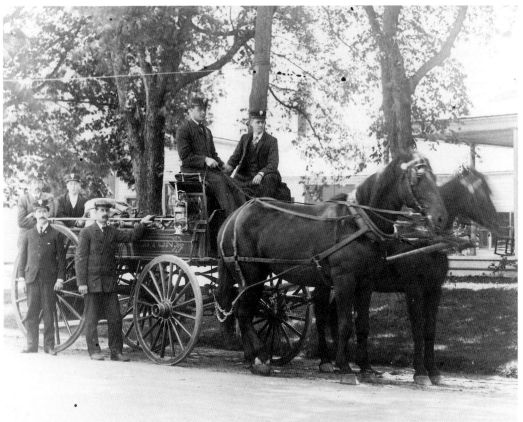

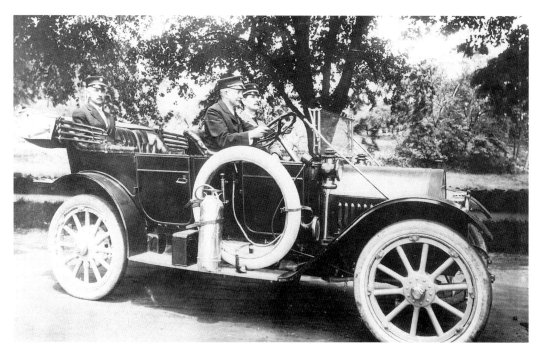

Above: The Weston Fire Department provided an invaluable service to the town. All the members were volunteers. In 1913, the department was kept busy, putting out five house fires and six chimney fires. One house and one barn were lost completely. Although fires were generally extinguished efficiently, the department did experience some major difficulties in responding to one alarm in 1907. The hose wagon got under way, but the horse refused to pull the wagon. The ladder truck horse fell down at the start, and when set on his feet again and started a second time, he and the harness parted company. The third time was more successful, until the driver discovered that he had lost his whip. In the meantime, the chimney fire at Darius Vittum's house had burned itself out. The fire department had "a fine time exercising," according to The Waltham Free Press.

Opposite, above: Town Hall, facing south from the north side of Boston Post Road near First Parish Church, combined town offices, classrooms, and the fire station down below in back. A grand ball was held to celebrate its opening in February 1848. All the young ladies purchased new ballgowns to wear to the event. Weston High School classes met upstairs in the hall between 1854 and 1878.

Opposite, below: Town leaders and young men alike volunteered for membership in the fire department, which became a popular social organization. Brenton Dickson Jr. is shown here dressed in uniform, wearing his fire department hat and driving a 1910 Chalmers automobile in the 1913 bicentennial parade. Ross Parker has joined him in the front, with William Tozier riding in the back. A strong sense of community encouraged these businessmen to volunteer for the department. In 1911, a bill was introduced in the Massachusetts Legislature to create a Greater Boston Federation by annexing surrounding Boston towns. The response in Weston, however, was swift and negative. The bill failed to pass; even now, the town continues to defend its rights to local control. By holding town meetings, Weston encourages voter participation. Moreover, debates at town meetings provide excellent entertainment for townspeople interested in local issues.

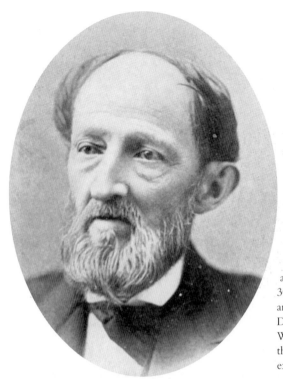

Service to the town was a family tradition. George W. Cutting, who lived from 1805 until 1885, was founder of the general store and also sexton at First Parish for more than 30 years. His son Alfred served as a selectman and as a representative in the state legislature. During Alfred's years of service as a selectman, Weston achieved financial stability. In 1908, the town had no debt, and revenues exceeded expenses by $24,000.

With more than 20 town offices to be filled each year, some residents were elected to town offices for decades. While "tythingman" and "hoggreave" no longer elicit competitive elections, the town remains dependent on its elected citizens, who serve without salary. Nakum Smith, pictured here in 1900, served on the school board for 15 years. He also made more than 29 transatlantic crossings before 1910.

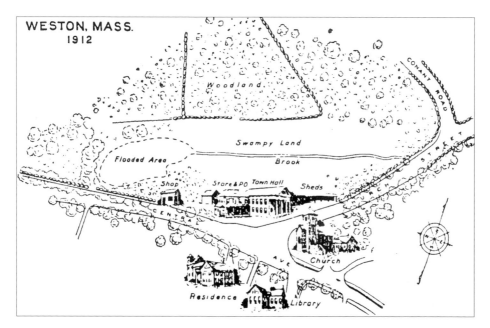

Here is a drawing of the Town Green from 1912. The re-design of the center of the town became a model for other rural communities. An issue of the Farmers' Bulletin, published by the Department of Agriculture in 1923, encouraged other towns to end the "squalor" and "ugliness" that had characterized Weston before 1917. The 1912 drawing shows the swampy land, drained to create the Green. The residence across the street from the store and post office is the Josiah Smith Tavern.

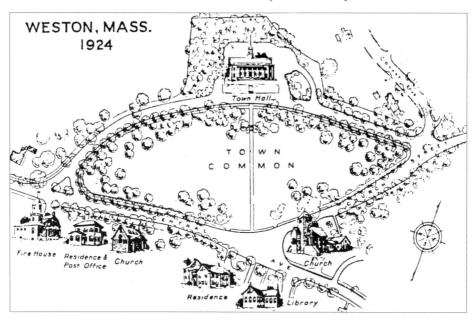

This drawing of the Town Green from 1924 shows a large area common with trees. Town Hall is prominently featured on a rise to the northwest of the major intersection at Boston Post Road (then Central Avenue) and School Street. The brook and swampy land have since disappeared, due to the installation of a drainage system. No permanent structure may ever be erected on the Green.

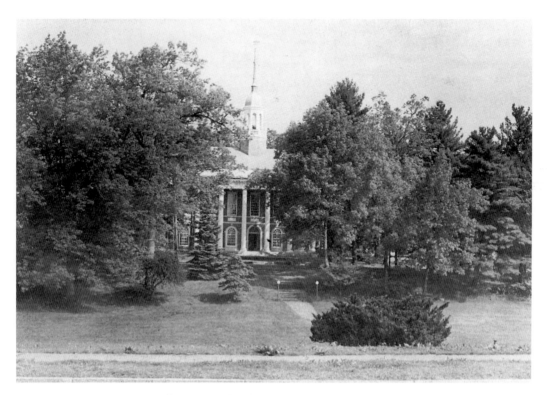

The Town Green and Town Hall were completed in 1917 under the direction of Arthur Shurtleff, a landscape architect, and Bigelow & Wadsworth, Boston architects. The hall was completed at a cost of $94,992.75, which was under budget by $7.25. In designing the landscape features, Shurtleff was influenced by his association with Frederick Law Olmstead. Olmstead used the natural terrain as the basis for his designs and instructed that native trees, shrubs, and groundcovers be selected for plantings. Shurtleff was awarded the contract based on excellent recommendations from several local estate owners who had previously contracted his services for their gardens and grounds. Shurtleff's plan involved moving the stream and pond underground to create a large and dry expanse before Town Hall. The above photograph shows the mature trees and plants on the Green. Note the flagpole rising above the trees on the right. The Town Green continues to be a focal point for town activities, along with impromptu frisbee games.

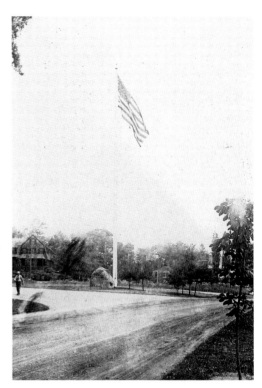

Right: The flagpole, originally erected at the intersection of the First Parish Church and the horse-watering trough in 1890, was moved east of Town Hall around 1919. The flagpole was originally erected with $250 voted during a town meeting. A memorial tablet, recording the names of Weston soldiers who died in World War I, was placed on the boulder at the base of the pole.

Below: The town continued to improve its Green. This photograph from March 1948 shows rocks being removed. In typical New England fashion, rocks continually work their way to the top of the soil. St. Julia's Church stands across Boston Post Road from the Green. Fifty years later, the center is frequently filled with walkers, bicyclists, and automobiles on sunny weekend days.

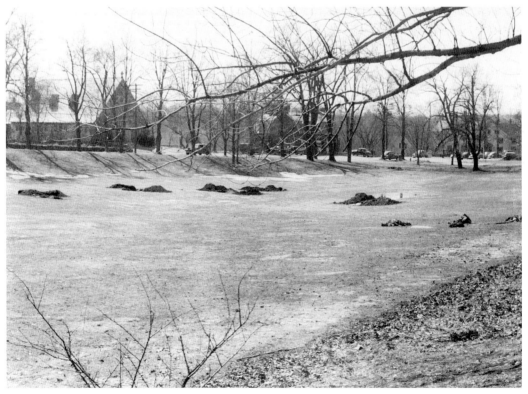

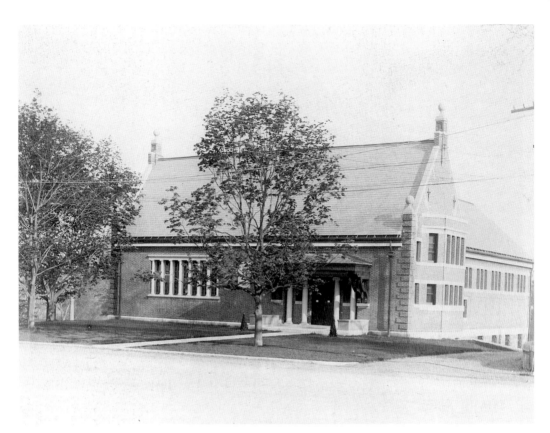

The new library, located across the street from Town Hall, opened in 1899. Originally established in 1857, the popularity of the library soon established the need for a separate facility. The first library was paid for by voluntary contributions and open on Saturdays from3 to 5 p.m. and from 7 to 9 p.m. It was available to persons aged 16 and over, and librarians received a salary of $40 per annum. A few years later, the librarian reported an increased demand for "books of a high intellectual order" and less demand for "time-wasting" fiction. By 1881, there were more than 5,000 volumes in its collection. Oliver R. Robbins, a library trustee for 31 years, received thanks in the town report for his efforts in making the new library possible in 1899. The report attributed "the transfer of the Library to its new building and its subsequent growth and development and increased usefulness to his business sagacity, literary judgment, forceful methods, and unsparing use of his time and energy."

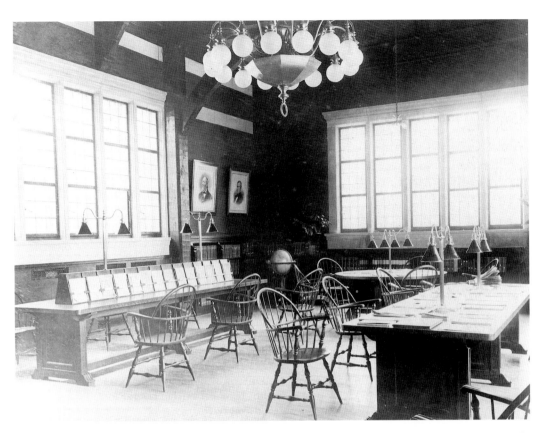

The new library featured an open-shelf system to encourage "the public to make their own selections." The town reports listed each book purchased by the library. In 1900, the list covered more than 50 pages, with over 12,000 volumes. Circulation numbers were also high. The population of 1,710, including 240 students, took out more than 13,000 books that year. The library trustees expected people to read for both pleasure and self-improvement, but they continued to express disapproval over the amount of time patrons spent reading fiction. Miss Louisa Case donated the children's room in memory of Rosamund Freeman in 1922. Margaret Mosher, already a member of the staff, became the children's librarian and served in that position for 39 years. The children's room offered many opportunities for children, starting them on their way toward becoming regular library patrons. Weston continues to enjoy the highest circulation of books per resident of any town in Massachusetts. A new town library was opened in 1996.

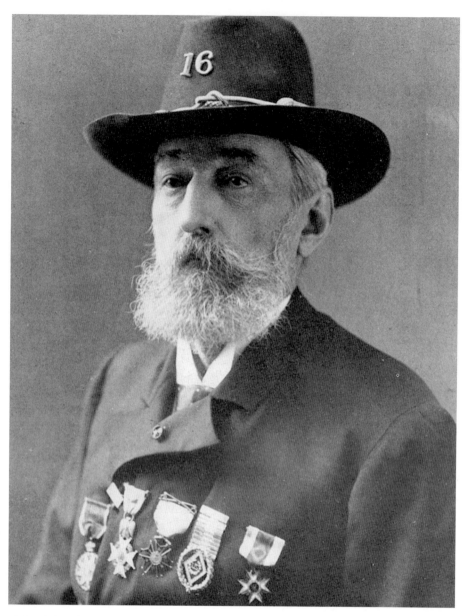

Colonel Daniel Lamson (1828–1912) was a descendant of John Lamson, who settled in Weston in 1714. The Lamson farm stretched from Viles Street to Boston Post Road. Colonel Lamson himself was educated in France and then at Harvard Law School, although he never practiced law. In the months preceding the Civil War, he organized and drilled a home guard before leaving for service at the front when war was declared. According to town historian Brenton H. Dickson III, he was nicknamed "Cover My Retreat" Lamson. Lamson wrote the History of the Town of Weston, Massachusetts, 1630–1890, the most complete history of those years and a valuable source of information on individuals living in Weston. Samuel Lamson, another ancestor, was the officer who gathered the train band for the march to Concord on April 19, 1775. He later served as a captain at Dorchester Heights with George Washington.

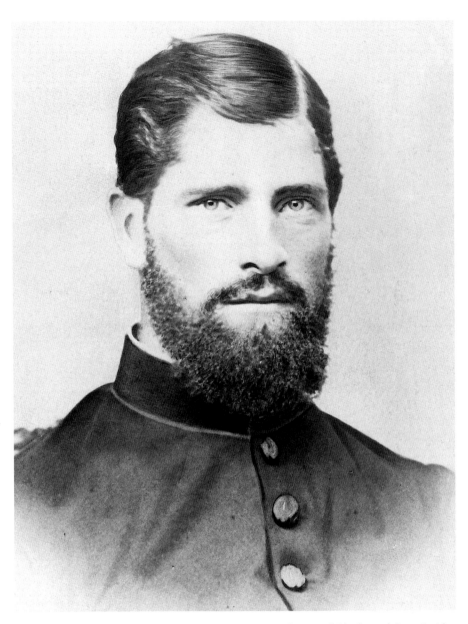

Frederick Augustus Cutter was born in Weston in 1825. The son of Charles and Anna Smith Cutter, Frederick served in the Union Army as a member of Company K, 32nd Regiment, Massachusetts Volunteers. He married Evorah Cushman of Newton in July 1862 and was killed one year later at the Battle of Gettysburg. He is buried in the Central Cemetery. With a population of 1,400, Weston was required to send 17 men to the Civil War. One hundred twenty-six Weston men served in the war. Eight died on the battlefield, three died of wounds in the hospital, and one, a member of the U.S. Navy, died in the Andersonville prison camp. The town raised $12,500 for the war effort through local taxes and $5,000 through voluntary subscriptions, a large sum for a small town. Town expenses included paying bounties of $100 to young men to encourage them to enlist in the army and paying to bring home the bodies of Weston soldiers killed on the battlefield.

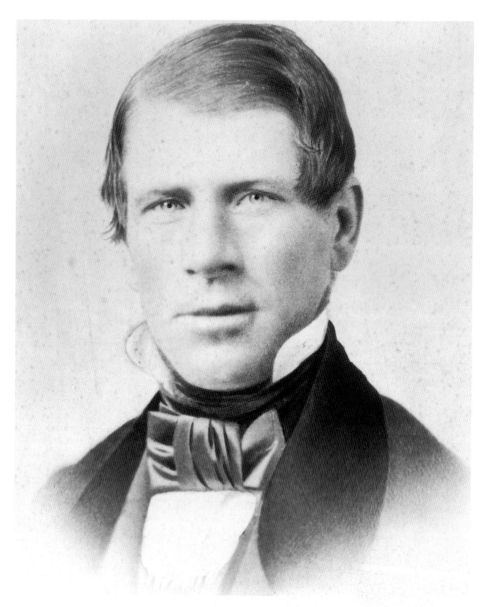

Edmund Lewis Cutter, Frederick's brother, joined Company I, 44th regiment, Massachusetts Volunteers. He died in the Newbern, North Carolina Regimental Hospital from diphtheria and pneumonia in April 1863. The town continued to send men to fight in later wars with more than 150 Weston men serving in World War I. Five did not return. On the home front, Philip Coburn learned military skills at a summer training camp and commanded the drill units at the high school. Only the boys marched with wooden guns. Weston was the first town over the top in every Liberty Loan Drive and supported the Red Cross, the YMCA, Knights of Columbus, and other patriotic enterprises aimed "to raise funds to cheer" the armed forces. Immediately following Pearl Harbor, the Weston Post of the American Legion maintained an aircraft observation post at the water tower on the Regis College campus. The post was manned night and day by two members for the next year. More than 500 residents served in World War II, including 119 women. Twenty-one died.

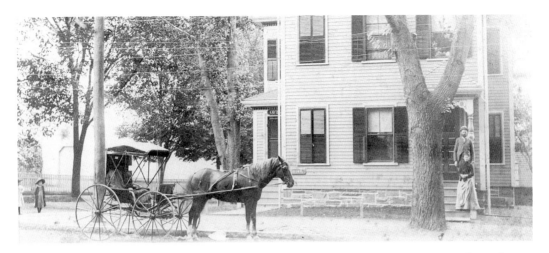

Dr. Leonard Brown's carriage stands waiting before his house as the doctor prepares to make a call. Good health was a priority, and the town report included a tabulation of diseases suffered. The town voted in 1809 to require a general smallpox inoculation. Tuberculosis was the most serious threat in the 19th century. The health of most Weston residents was excellent, a condition attributed to the high quality of the water.

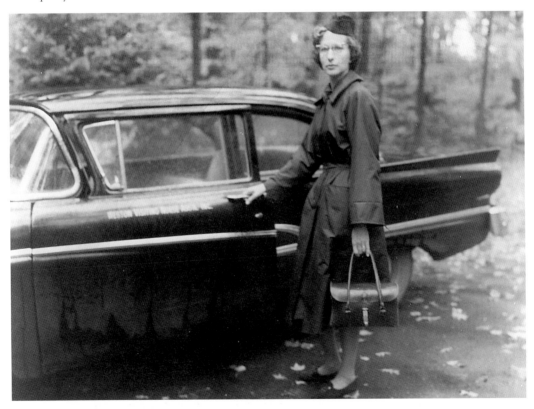

Jane Hosterman, R.N., representing the Visiting Nurse Association, drove a 1957 Ford Fairlane to visit her patients. She was also a school nurse. Volunteer contributions helped the needy in the years before government programs. Charles Merriam donated $1,000 in 1865 to establish a fund for the "silent poor."

Philip A Coburn, born in 1900, grew up in a house on the land owned by the Coburn family since 1801. His reminiscences, described in Growing Up in Weston, include early memories of going to Norumbega Park across the Charles River in Newton to ride the merry-go-round and to see the vaudeville show. At five, he went to school by barge (a large wagon with seats) or pung (a large wagon on runners to travel over the snow). For fun, he rode his bicycle, caught perch and pickerel, played "pick up" football without a helmet, and counted the number of automobiles passing by on Church Street on Sunday afternoons, when he was not allowed to play sports. Coburn had many ties to the community. His uncle Arthur was president of the Hastings Organ Factory, and his aunt Anna had married the owner of the factory, Francis Hastings, whose relatives were numerous in town. Coburn continued to live in Weston until his death in 1983.

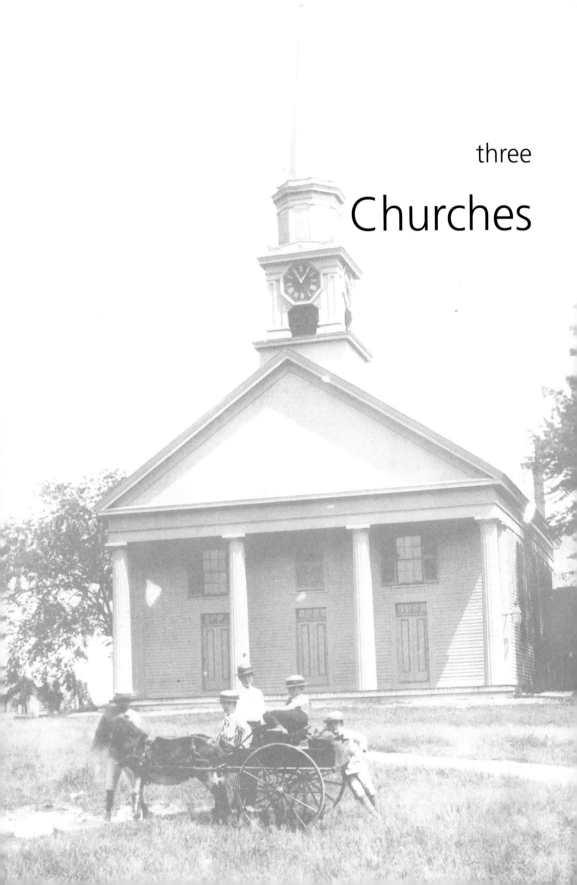

three

Churches

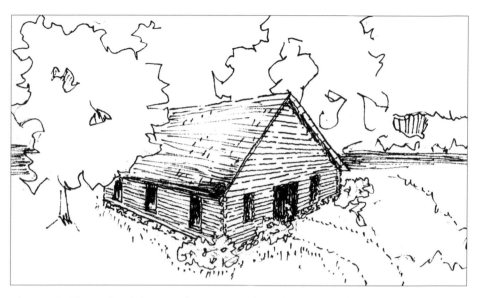

The First Parish was founded in 1698 by Puritan settlers. The 1888 building, shown in the photograph above, is the fourth for the parish. Two generous benefactors of the church, Horace Sears and Arthur Coburn, suggested a new style they had admired during a trip to Europe. The building was constructed of native field stones supplied by parishioners from their farms. The Unitarian Universalist Church continues to be a landmark.

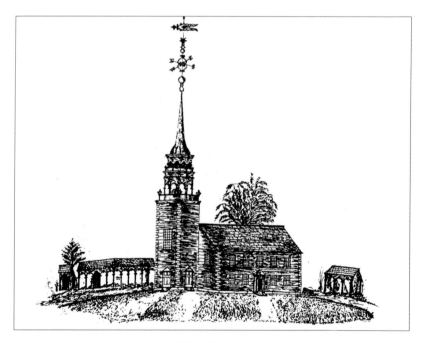

A new, larger meetinghouse was built in 1721. The exterior was built of solid oak timber with large windows, square pews, and a raised pulpit inside. A small bell, captured by Weston soldiers in Canada, hung in the bell tower. As part of the 1800 renovation, a steeple was added to the tower and a much larger bell, costing $72.88, was ordered from the Paul Revere Foundry.

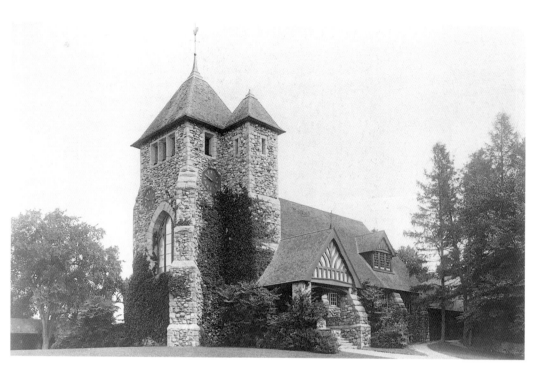

Above: Originally Watertown residents, Weston farmers petitioned the General Court to allow them to establish a separate precinct and meetinghouse from Watertown. Their request was finally granted in 1698. Parish records describe a rough 33-square-foot structure built of logs, with wooden benches and dirt floor. The 18 male members and their families were called to worship by a beating drum. The building, used for 24 years, was never completed.

Right: The third church (1840–1887) of the First Parish was built in the Greek Revival style. The Massachusetts Legislature adopted the Jeffersonian principle of separation of church and state, and the new law required that both a new church and a new town hall be constructed. The older meetinghouse was dismantled, with its materials and furnishings sold at an auction. Many parishioners were sorry to see the old church removed. Col. Daniel Lamson wrote, "There was an air of solemn dignity, an emphasis of religious fervor, which this old church typified, that empresses the beholder with a reverence its successor never succeeded in doing. The destruction of this old landmark . . . shows both a lack of reverence and the decay of faith—a marked trait of our times." Town Hall was not completed until 1847.

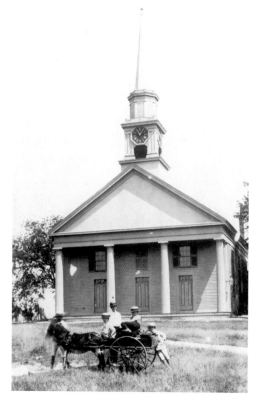

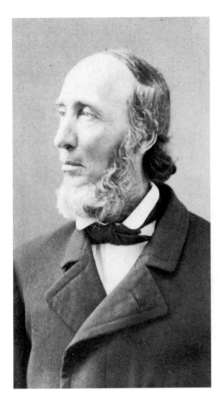

Left: Dr. Edmund Sears (1810–1876) wrote "It Came Upon The Midnight Clear" in 1849. Sears preached against the Fugitive Slave Law in 1850 and condemned South Carolina Senator Preston Brooks' assault on Massachusetts Senator Charles Sumner in the U.S. Senate in 1856. Reverend Sears came to First Parish Church in 1865, where he preached until 1875. Lydia Maria Child admired his courage in pleading the causes of women and the enslaved.

Opposite, above: The First Parish Church, built in 1888, was based on the Norman Gothic churches of the English countryside. The photograph shows the interior before the installation of the Hastings organ in 1917. In his sermon on the 275th anniversary of First Parish, Reverend Henry Hoehler said "Building a Norman Gothic structure in a Puritan country town was not without its critics."

Opposite, below: Large banks of flowers decorated the pulpit of First Parish on Easter in 1906. The church raised funds for the Montana Indian School, the Waltham Hospital, the Meadville Theological Seminary, and the First Parish building fund. A major part of the fund-raising was done by the Friendly Society, founded by Reverend Charles F. Russell in 1885. The Friendly Society produced at least two theatrical productions each year.

The First Parish Parsonage, built c. 1702 at the corner of Wellesley Street and Maple Road, is the backdrop for this late-19th-century photograph. Deacon White, town treasurer, stands to the left with Charles M. Eaton, then the principal of Weston High School. Residence in the parsonage provided a substantial amount of the compensation for First Parish ministers. Early ministers farmed to supplement their incomes.

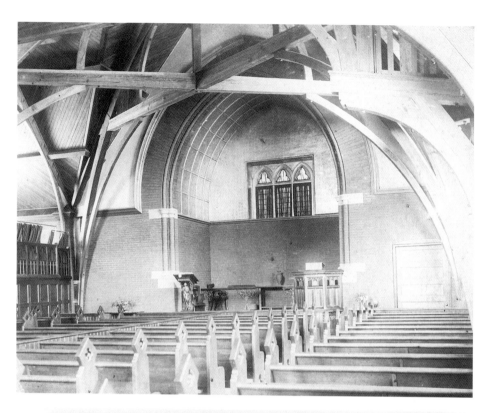

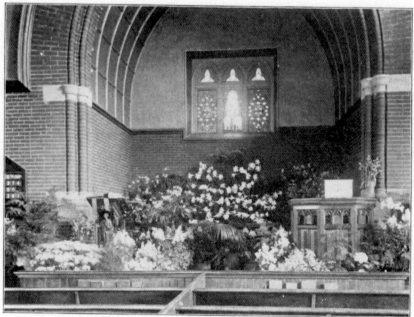

Easter Greetings from Mr. and Mrs. Francis H. Hastings.
"Seven Gables." Kendal Green. Mass.

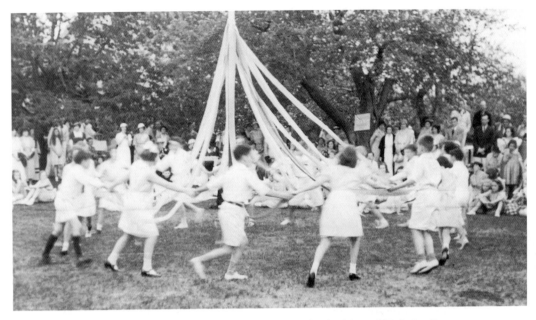

Louisa Case held an all-day "May Party" on May 20, 1933, on her land east of Wellesley Street to benefit the Music Committee of the First Parish Church. While the pet and hobby show and the baby show offered prizes, the May pole was a favorite. Miss Case inherited the summer estate "Rocklawn" from her father, James B. Case, who was the president of Bates Textile Manufacturing and director of the First National Bank.

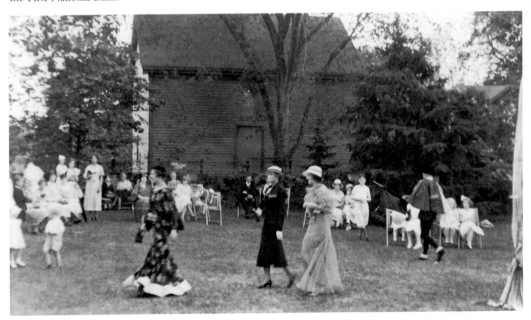

Mrs. Philip Coburn leads the fashion show at Miss Case's party. The dresses came from fancy shops on Newbury Street in Boston. The protective strip on the hem of Mrs. Coburn's flowered dress made certain the dress could be returned and sold. As the town settled into the depths of the Depression, events such as this May Party helped to raise spirits as well as funds for church programs.

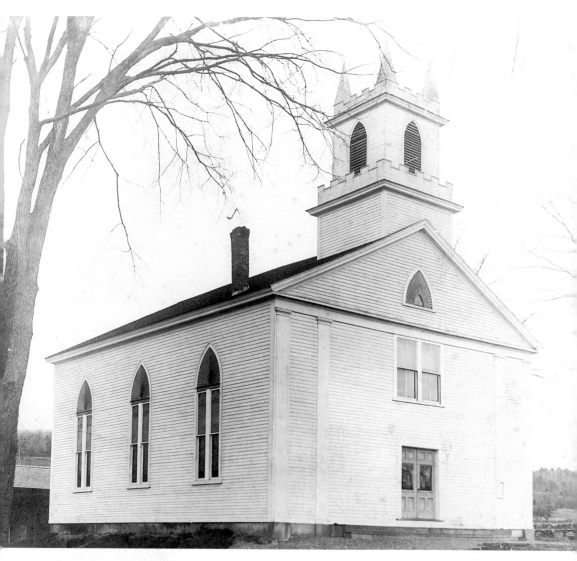

The Methodist church was the second church established in Weston. It had its beginning when a Methodist circuit rider held an open-air meeting in 1790. Bishop Francis Asbury visited the area in 1791 to establish a Methodist class at the Bemis homestead, Winter Street, Waltham. Reverend John Hill, the first minister, was appointed in 1794, three years before the first Methodist church was erected. It was the fifth Methodist church in the state. Early members paid taxes to support the First Parish until the church and town were separated in 1825. The original church, pictured here, burned in 1899. Church events offered residents many opportunities for social activities. In 1907, members of the Sunday school and Ladies' Aid enjoyed their annual August picnic in a grove owned by N.S. Fiske. A large open space gave ample room for games. The dinner, served at noon, consisted of sandwiches, pickles, cakes of all kinds, bananas, and ice cream. The Methodists were the second of many religious denominations to establish churches in town. Eleven separate congregations hold services in Weston today.

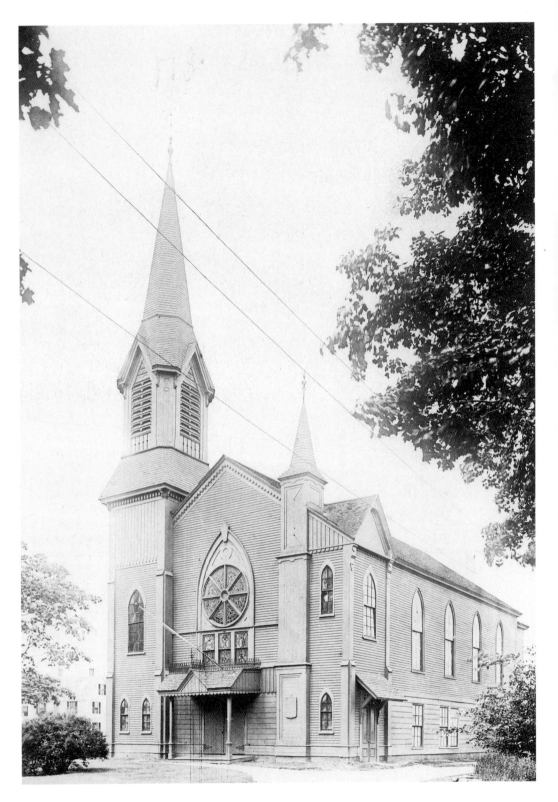

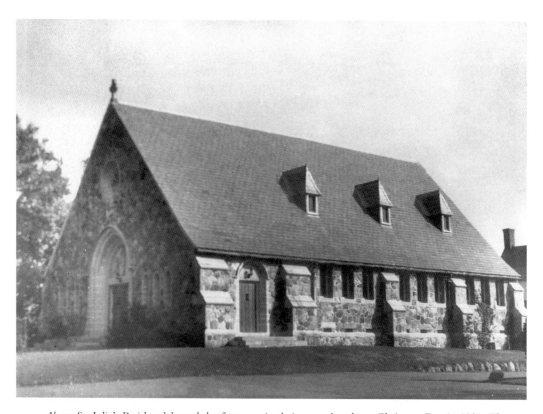

Above: St. Julia's Parish celebrated the first mass in their new church on Christmas Day in 1921. The first Catholics living in Weston went to Waltham or Wayland to hear mass. By 1917, mass was held in Town Hall, where Catholics worshipped at one hour and Episcopalians at another hour. Reverend William J. Foley (1919–23) chose St. Julia as the church's patron in memory of his mother. The church, located in the town center, served some 100 members and confirmed 35 Weston children in 1922. Mrs. William Filene, Weston resident and wife of the director of the Boston store, was a benefactor of the parish. During the Depression, she sent many grocery orders to the rectory and, in later years, supplied refreshments for card parties, on one occasion sending 200 turkey sandwiches. The parish established a beneficial association with Weston College established by the Jesuits and later with the Pope John XXIII National Seminary for Delayed Vocations, both in Weston. The growth of the parish required major additions to the church in 1962, and again in 1996 with a new rectory and parish center.

Opposite: The Baptist Society first won converts in Weston in 1784. Membership grew substantially, and by 1825 the Weston Baptists separated from Framingham Baptists to form their own church. They joined Weston Methodists in 1822 to protest against "illegal assessments for ministerial tax, ringing bell, providing wood, and repairing the meeting house" for the First Parish. The first Baptist church, located in the southern part of town, was inconvenient for the majority of its members. In 1828, a wooden frame building was constructed across the street from the Golden Ball Tavern. The original building was razed in 1923 to make room for the existing brick structure. The church sponsored many activities at the turn of the century: "six-cent" suppers, stereopticon talks encouraging donations to the Oklahoma mission, and picnics at Boone Pond in Hudson. Baseball games against the Sudbury High School team provided the entertainment at the Boone Pond picnics, though Sudbury frequently won the contests.

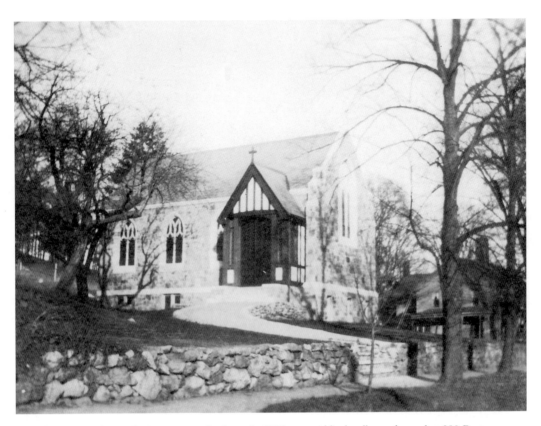

Episcopal services began during summers in the early 1890s at an old schoolhouse located at 280 Boston Post Road. Later, Reverend Arthur Papineau, rector in Maynard, added Weston to his care, riding his bicycle 17 miles to give a 3 p.m. Sunday service at "Laxfield," the home of Mrs. Andrew Fiske at 81 Concord Road. Services moved to the old Town Hall and then to the first St. Peter's, shown above, in the town center in 1918. The growth of the town and the parish after 1941 led to the construction of a new church at the corner of Boston Post Road and the By-Pass. The new church was dedicated in 1958. The members of the Christian Science Society purchased the original St. Peter's for their church and reading room. The Christian Scientists held their first Sunday services in Town Hall in 1950. Nine years later, the Society was recognized by the Mother Church and became the First Church of Christian Scientist, Weston.

four

Education

Right: Anna Cutter Coburn was valedictorian of the Weston High School Class of 1871, a class of seven students. From 1872 to 1898, she taught at the high school, intermediate school, and (for the last 16 years) the Northeast District School #4 on North Avenue. In a typical year, she taught 54 scholars, with average attendance of 36, in one room. The school committee commended the order, neatness, and inspiration she created in her school.

Below: Anna Cutter Coburn (1853–1950) married Francis Hastings, the owner of the organ factory, in 1899 and retired from teaching. She was 46 years old and he was 63. Mrs. Hastings continued to contribute to the community through her activities in the Friendly Society, the Women's Community League, the Waltham Hospital Aid Society, the Weston High School Alumni Association, First Parish Church, and the Republican Club of Massachusetts. Her volunteer efforts were typical of many town residents.

Opposite, above: Six new schoolhouses were built in Weston in the early 1850s. The teacher in the Southwest District School, shown above, taught all eight grades in one room. The accomplishments of the pupils were noted in the annual town report, as was the attendance record for each child. Several children maintained perfect records during their 12 years in school. A small airport was located behind the site of the school until 1931.

Opposite, below: The graduates of the Northeast District School at Kendal Green gathered for a reunion in June 1893. The program included a reception, "rambles and games," which included tennis at Mr. Hasting's house, and a supper followed by brief exercises in the large tent. The exercises included a history of the old school and the singing of "Auld Lang Syne."

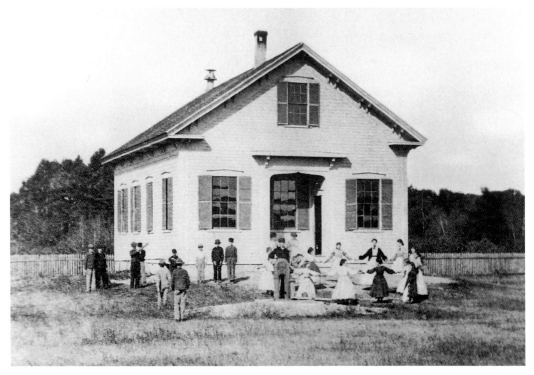

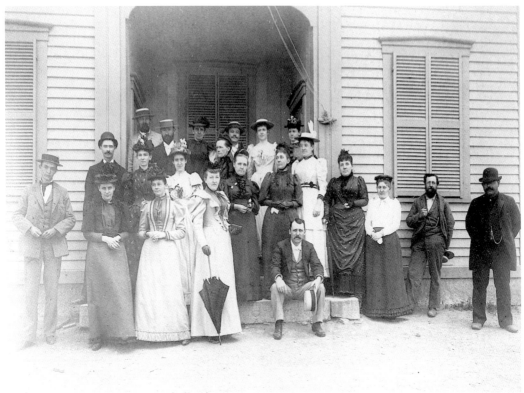

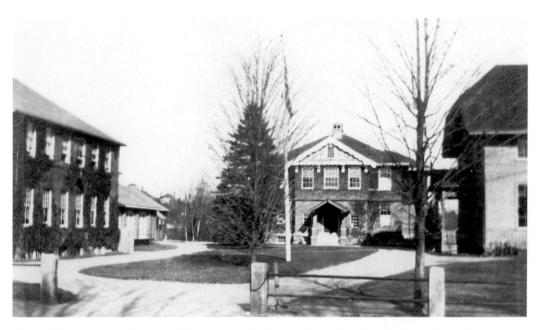

Above: Weston responded to the call for educational reform and centralized its schools on School Street. The primary school is in the center, the high school is on the left, and the grammar school for grades five through eight can be seen on the right. The school board planned to improve instruction by setting up classes by grade level. Manual training classes were taught in the building behind the high school.

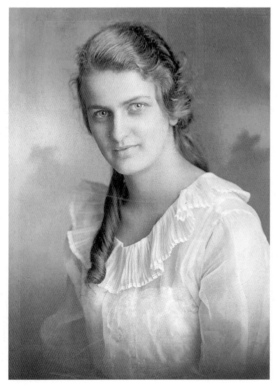

Left: Alice Tyler Fraser enjoyed her high school years, especially attending school parties and dancing in the auditorium after lunch. Her aunt made the organdy white dress she wore in 1920 to the graduation ceremonies and the evening party given by the WHS Alumni Association. Miss Green, a mathematics teacher, suggested that Alice should apply to Boston University. Alice was admitted, graduated, and taught English in Wellesley for many years until her retirement in 1965.

Opposite, above: Centralizing the schools led to controversy. Some students preferred the larger classes held in the building on School Street, but some parents preferred neighborhood schools. Alice Fraser, for many years curator of the Weston Historical Society, sits on the bench second from the left. Half the members of the sixth grade class, pictured here in 1914, continued on to graduate from Weston High School.

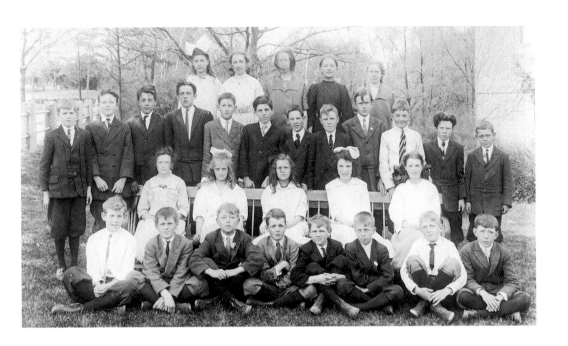

Below: The high school graduation on the Town Green, in the 1920s and today, is an important town event. The tradition of white lace dresses and formal wear continues to the present day. Before the creation of the Town Green in 1917, graduation took place in the high school hall. In 1912, eight boys and five girls received their diplomas in the school hall trimmed with hemlock, palms, and blue and white irises. Three young men received $10 gold pieces for greatest improvement, good standing despite discouragement, and highest general standing. No prizes were offered to the girls. In later years, Mr. and Mrs. Francis Hastings came forward to offer prizes for the girls as well.

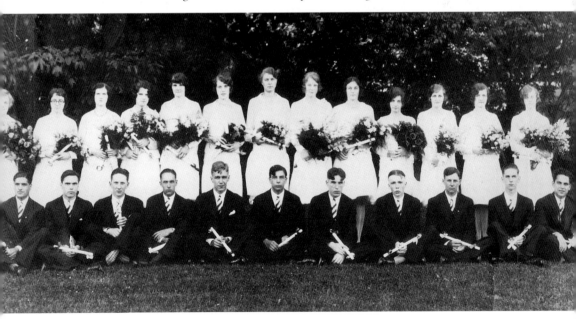

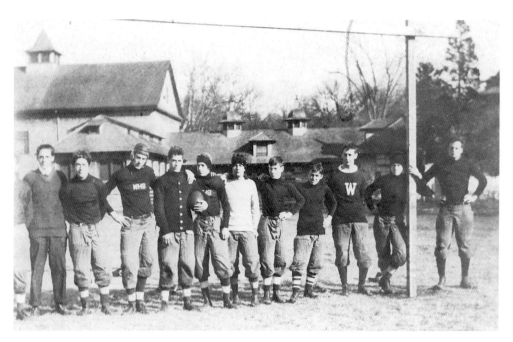

Because there were not enough boys to play, there was no official football team at the high school from 1910 until 1920. Weston pick-up teams played similar teams from Waltham, Newton, and Wayland in informal games. Such games, however, often resulted in concussions and broken bones. This photograph of the 1911–13 pick-up team was taken at the Winsor estate, where the boys were given a field for practice.

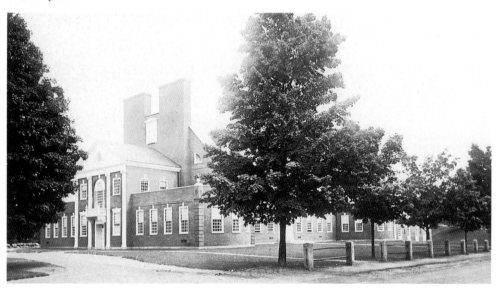

From 1895 to 1928, Charles M. Eaton served as superintendent and principal of Weston High School, located on School Street. Eaton encouraged his students to strive for the best. Philip Coburn described Eaton as a strict disciplinarian: "You rose to your feet and stood at attention when he spoke to you. It didn't matter whether you were in school or out . . . on the grounds or in the village, you were always under his jurisdiction."

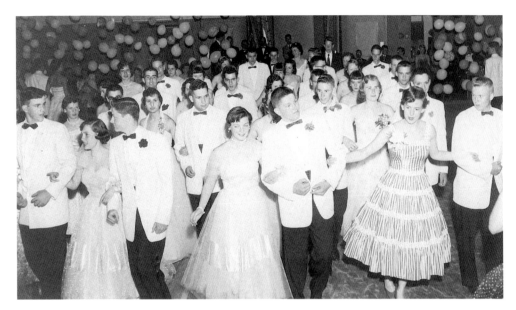

High school proms of the 1950s carried on well-established traditions. Students decorated the high school gymnasium, now the Field School gymnasium, for the dance. In May of 1912, the juniors gave a reception for the seniors, with 40 students present. The school hall was tastefully decorated in blue and gold, the senior colors. One hour of games, followed by refreshments and dancing, made up the evening's entertainment.

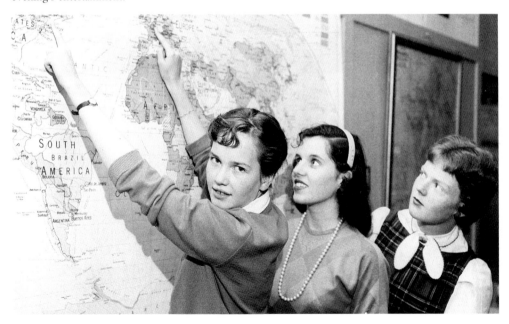

Weston High School students measure the distance to France as they prepare to apply for the Rombas exchange program in the late fifties. The Weston-Rombas Affiliation sponsors the exchange, which now includes a second program with Porto Alegre, Brazil. Exchange students learn to live in another culture while improving their proficiency in French and Portuguese. Students live with families while studying at the local high school.

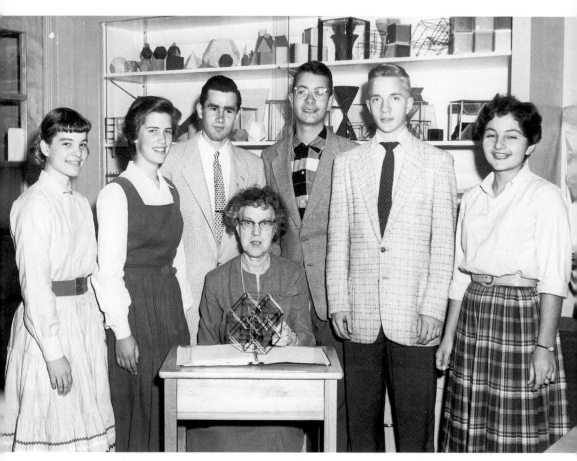

Helen B. Green taught mathematics at Weston High School from 1916 until 1959. She graduated from Boston University in 1910 and pursued graduate studies at Clark University, the University of Connecticut, and Harvard University. Mathematics was her passion, and in 1949 she founded the math club. She started the first girls' basketball-throwing practice and prepared the first girls' field hockey team. Miss Green was the yearbook advisor and president of the Weston Teachers' Club, the predecessor of the Weston Education Association. In her retirement, she continued to teach part-time at Lasell Junior College in Newton until she was in her late eighties. Dr. Jerry Kellett, former mathematics teacher and Woodland School principal, described Miss Green as "a wonderful lady, unpretentious, strong, and influential."

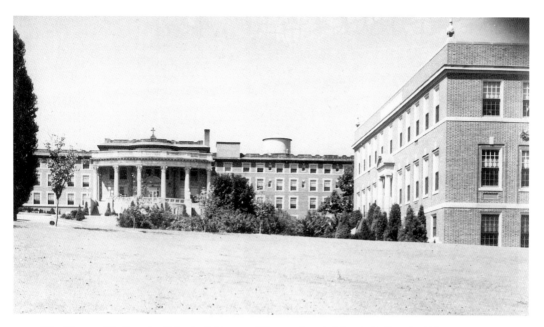

The Sisters of St. Joseph of the Archdiocese of Boston founded Regis College in 1927. Fannie Morrison sold her estate of 170 acres with four buildings and a water tower to the Order, which wished to establish a Catholic women's college. College Hall, shown above, was built in 1930 to provide more classroom space for the liberal arts college. By 1963, approximately 700 students were enrolled.

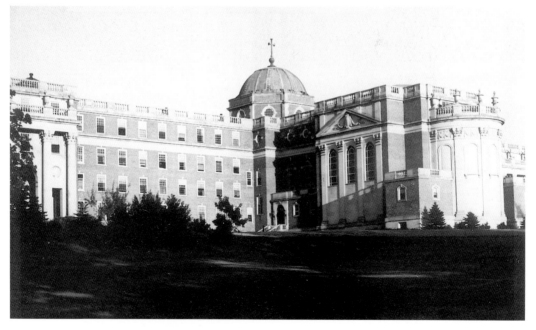

Weston College was built between 1921 and 1925 on Concord Road by the Northeast Province of the Society of Jesus. The college trained young men to be Jesuits, with the emphasis on philosophy and theology. In the 1960s, the facility became a health clinic and retirement home for Jesuits and a retreat center for lay people and priests. Classes were moved to the Weston School of Theology in Cambridge.

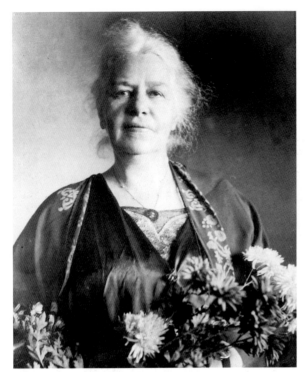

Left: Miss Marian Case operated the Hillcrest Farm from 1910 to 1943 at her estate on Wellesley Street, which later became the Case Estates of Harvard University. An ardent supporter of the Massachusetts Horticultural Society, Miss Case wanted Hillcrest Farm to be educational and self-supporting, relying on fruits and vegetables for income. The produce was sold in Weston and Newton. Local boys earned 4¢ per hour while receiving an unusual educational opportunity.

Below: The Hillcrest boys, shown here in the summer of 1938, learned how to garden, sell produce, and prune trees. Experts gave lectures at the farm every Monday. Each boy wrote a paper based on his observations of nature every week. Miss Case took the boys to Walden Pond, the Buffalo Bill Wild West Show, the Ringling Bros. Circus, and Nantasket Beach in 1910 to thank them for their hard work.

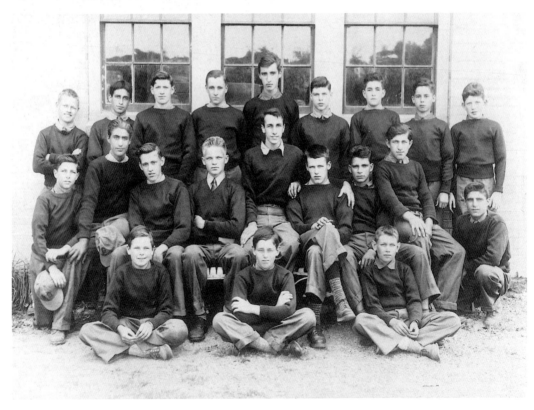

five

Farming

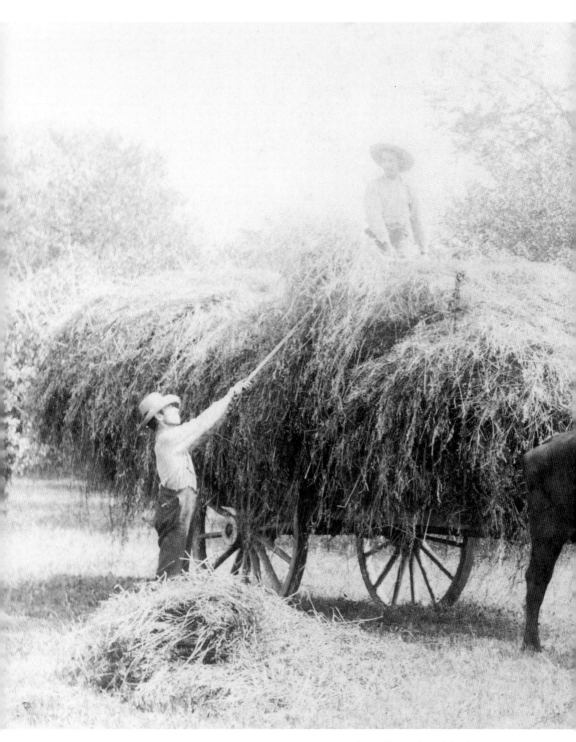

Hay-making was an important activity on local farms, despite the unfavorable quality of the land. Horses, cows, and oxen consumed large quantities of hay, and almost all farmers produced some hay. Oxen did the heavy work of farming and hauling, due to their great strength. It took three years to

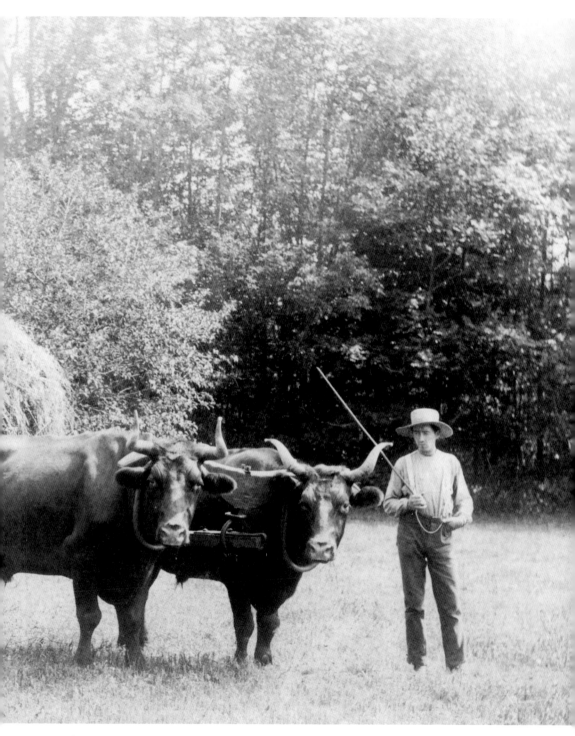

train them. Once trained as a pair, they would work with only their partners, and not with any other ox. The Carters used a pair of oxen at their farm, Woodleigh, on Boston Post Road until the late 1970s. Buster and Stubby were the last two oxen to be used for farming in Middlesex County.

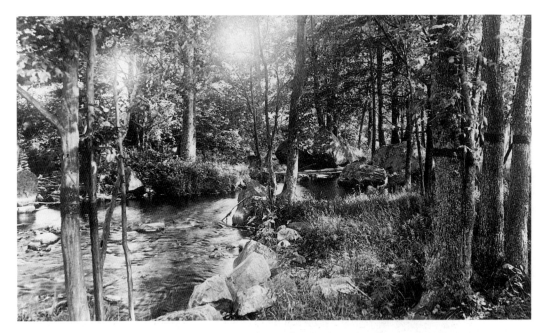

Above: Streams, such as Hobbs Brook, ran through the northeastern section of town, providing water for farm animals and power for mills. Many farms and early businesses were located in the village of Kendal Green. Many of the brooks in this area were later incorporated into the Cambridge water system. Note the bands of tanglefoot, tied to trees to counteract the 1909 Gypsy moth infestation.

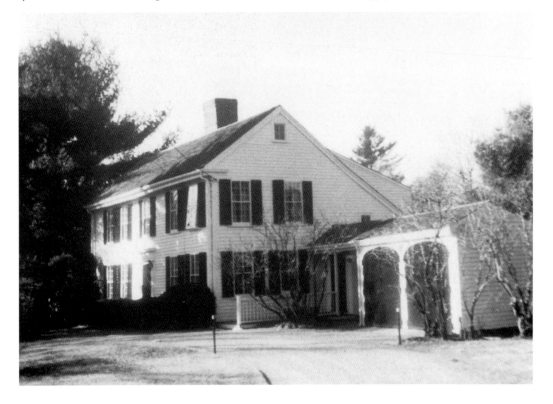

Left: Elizabeth and Henry Zoller purchased 114 acres of the farm on Conant Road in the late 19th century. Like many New England farmers, Zoller added to his income by taking other jobs. While plowing snow for the town highway department, he could always be recognized by the icicles hanging from his mustache and the rope that held his coat around his waist. This photograph, taken in front of the shed attached to the house, dates from 1903.

Below: Horace Sears built the elaborate barn in the background of this photograph in 1919. The Saddle and Bridle Club used the first floor as a barn for their horses and the second floor for badminton games and parties. The barn was razed with the rest of the Sears estate in 1946. Four-year-old Mary Lee Bennett (now Mrs. John T. Noonan Jr.) checks for the mail in this photo from 1941.

Opposite, below: John Walker built this farmhouse at 118 Conant Road about 1740. He farmed 200 acres with his son Isaac. The farm then passed to Isaac's son-in-law, Oliver Conant, and on again to Conant's son-in-law, Benjamin B. March. Farms frequently passed through four or more generations in the same family. Walker combined apple orchards with tilled land and pastures on his farm. Horace Sears purchased the farm from Elizabeth and Ebenezer Zoller and made it part of his extensive estate. Sears bequeathed the property to Helena Bailey, the wife of his business partner, who sold the farmhouse and 5 acres of orchard and woodland to Rosanna and J. Kenneth Bennett in 1947. The Bennetts continue to make the property their home. Like many farms in Weston, the house has retained its essential design, although outbuildings and landscaping have been substantially modified.

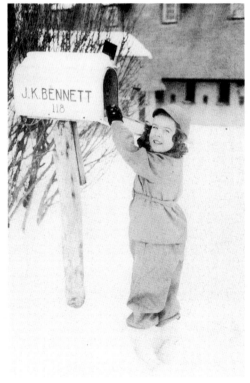

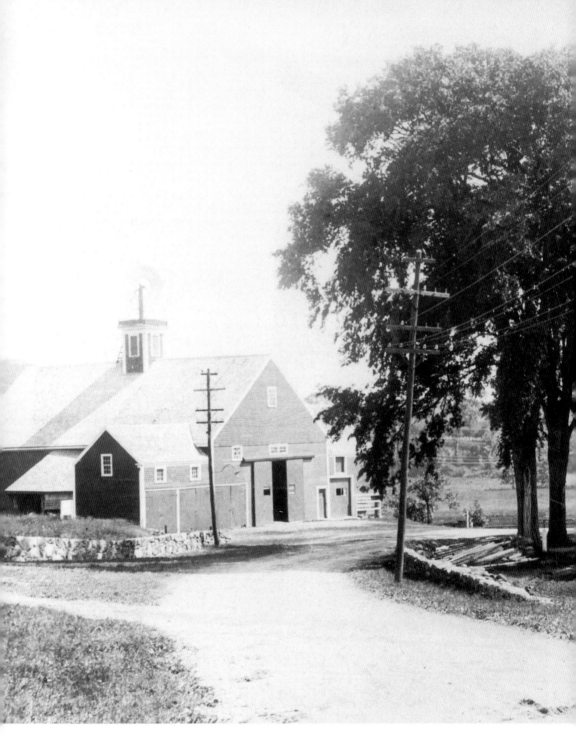

The Coburn homestead, found at 153 Church Street, is one of Weston's oldest houses. Jonas Coburn bought the house and farm of 120 acres in 1801 from Aaron Whittemore for $4,400. The house was built by Jeremiah Whittemore in 1726. It was believed that the elm trees shown in the photograph were more than 50 years old when Coburn purchased the farm. The large red barn was built in 1840. The

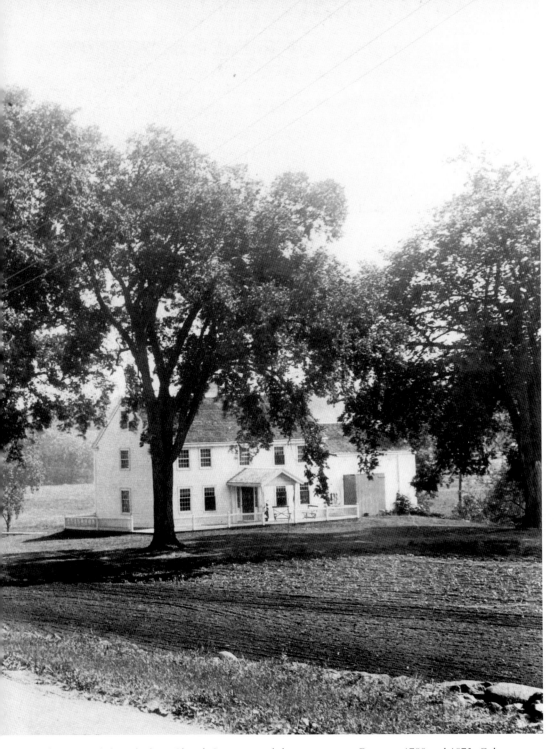

farm extended south along Church Street toward the town center. Between 1789 and 1973, Coburns spent 52 years serving as selectmen and 5 years serving as representatives to the Massachusetts Legislature. Coburn descendants owned the homestead until 1997 and still live in the town today.

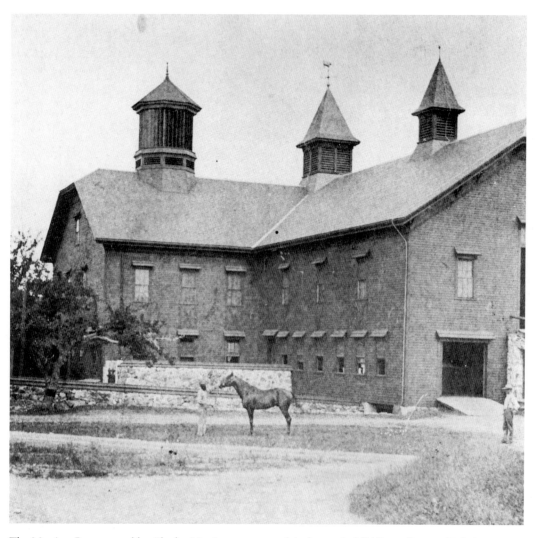

The Merriam Barn, owned by Charles Merriam, was one of the largest in Middlesex County. Built in 1876, the barn had three levels. It also had a large ramp that delivered hay to the top floor. From here, the hay was pushed down into feeding troughs. The cupola at the left housed a rotary windmill with vertical vanes to pump water into a large tank located under the roof of the barn. The supports for the tank eventually weakened, sending it all the way to the basement and killing a few cows. The second tragedy to strike the farm was an outbreak of hoof and mouth disease. This prompted the destruction of 60 cattle in 1915. Merriam's outstanding herd was driven into a long trench in a field below the barn and shot one by one. It was said that Charles died of a broken heart soon after. The final tragedy was the burning of the barn in 1926. All livestock were released safely while fire fighters focused their efforts on preventing the fire from reaching the house.

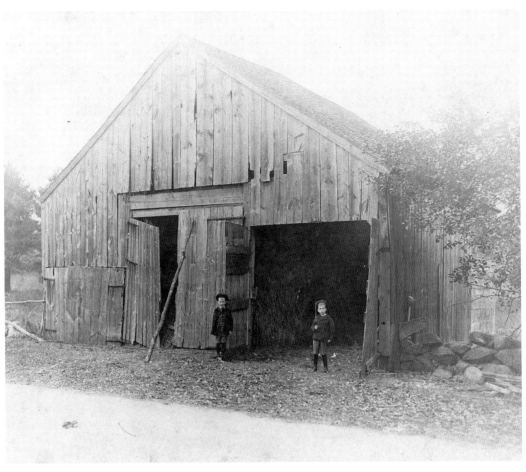

Two young boys, probably from the Upham family, were photographed in front of the Upham barn on Ash Street. A third boy is climbing over the fence on the left, perhaps late for the photograph. Note that the boys are dressed in their "Sunday's best." Having one's picture taken by a professional photographer was a special event. The boys would have known the barn and the farm well from doing their daily chores. Children worked on farms as soon as they were able to follow directions. This tradition was well established during the Colonial period, when school lasted three months at most. Boys attended in the winter, and girls went during the summer. The Upham family may be traced in Weston records from the earliest settlement to the present day. At the turn of the century, farming was still a major occupation in town, with the local census listing 1,012 cows. Transportation was provided by 500 horses and 25 automobiles.

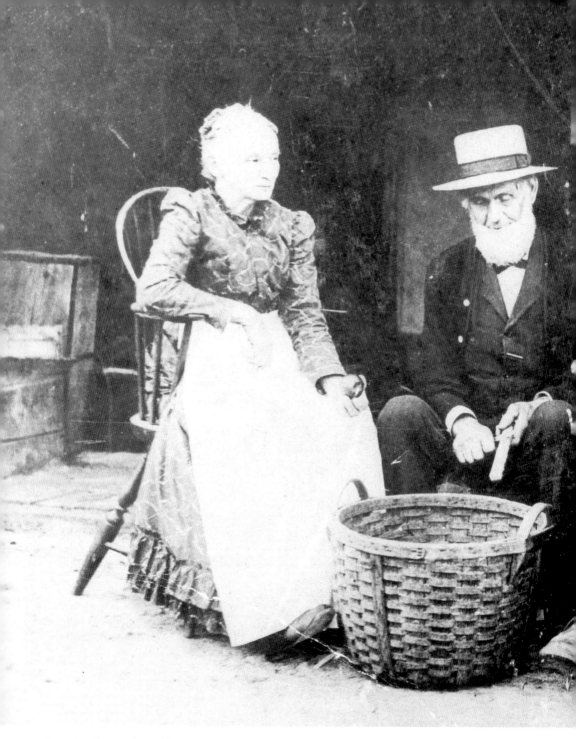

Corn, found in mush, pudding, and bread, was one of the most widely eaten foods in America. Here, Mr. Cutter scrapes the kernels from a cob. Mrs. Cutter is holding an apple, a product of the many apple orchards found on almost every farm. The rocky soil and numerous hills of Weston encouraged many farmers to plant apple trees and to provide pasture for cattle rather than tilling most of their farms. Farmers' wives led demanding lives tending crops, taking care of children, cooking, churning butter,

and making products for sale. This photograph of the Cutter family was taken at their farm around 1890. The Cutter farm remained in the family for four generations and was known for the excellent cider that was produced there for commercial sale. The farm was lost to the bulldozer when the Massachusetts Turnpike was constructed.

Alice Fraser was an expert rider. She is shown here in 1918 at age 15 in front of the stone barn of Ferndale Farm. She delivered milk for Frank Pope, who owned the dairy on South Avenue. Alice was respected by the cowhands for her ability to ride a bucking colt and bring him back to the stables under her control. Much of Ferndale Farm is now the Pine Brook Country Club.

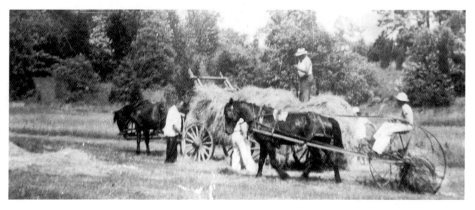

Giuseppe (Joseph) Melone directed the work from the top of the hay wagon as he harvested one of his fields behind the Sears estate in 1942. Charlie and Lightning pulled the wagon, while Polly pulled the rake driven by Giuseppe's son Tony. Giuseppe, an Italian immigrant, established a successful landscaping business in town. All of his children received many awards for academic and athletic excellence from the Weston public schools.

six

Business and
Industry

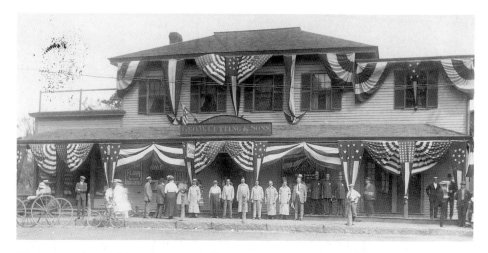

Weston was a regional shopping center before customers were able to speed into Boston by rail. George W. Cutting opened his general store in 1830. The store was in the center, facing south on the south side of what is now the Town Green. Here, the store is decorated for the 1913 Weston Bicentennial. Mr. G.W. Cutting Jr. and six of his employees stand in front of the store.

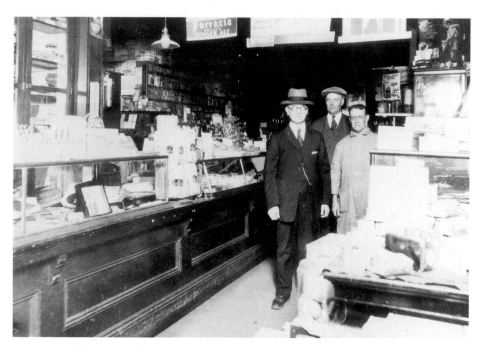

G.W. Cutting Jr. ran the family business after 1885, combining his responsibilities as store owner with serving as a selectman and a representative to the General Court. The store served as the center for much of the town discussion, placing Cutting in a position to know what was on the minds of the voters. Mr. Nims, a clerk in the store, is pictured here wearing a suit and hat. When the new Town Green was created in 1917, Cutting's store was moved across Boston Post Road and turned to face north. The store was located on a site later used by St. Julia's Church. When the time came to move the store, the building was moved one-half mile and remodeled to become the home now located at 36 Church Street.

Isaac Fiske acquired his law office in 1805 from Artemus Ward Jr., who moved to Concord to practice law. A graduate of Harvard in 1798, Fiske achieved success as a lawyer and served as town clerk for 24 years. Fiske left many legal papers and books; they are now in the collection of the Weston Historical Society.

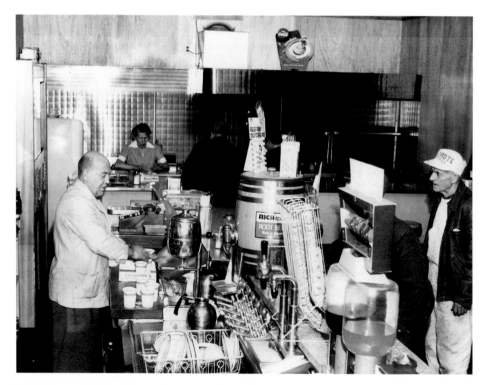

The Weston Grille in Weston Center was famous for its Sweet Araby coffee brewed by George LeTendre, the restaurant's owner. Mrs. Rose LeTendre is working behind the back counter in the newly remodeled portion of the restaurant. Remodeled in the late 1950s, the Weston Grille was a favorite spot for passengers waiting for the bus. The Grille was later known as Ye Old Cottage Too.

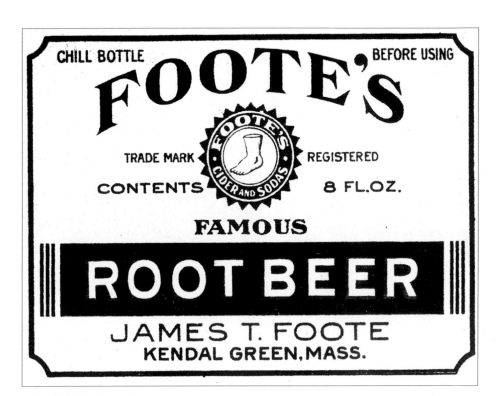

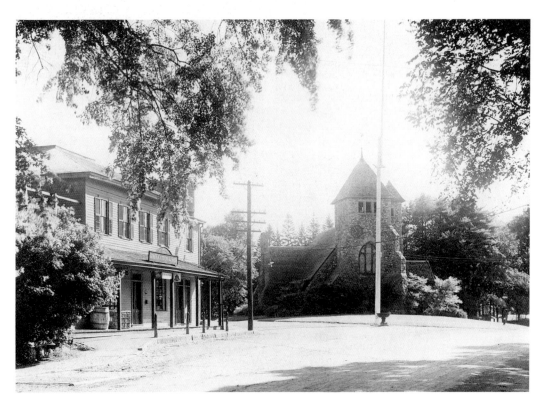

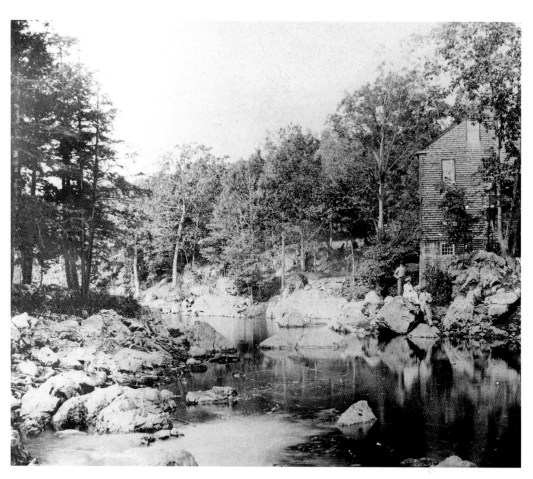

Above: The streams of Weston were a natural attraction for entrepreneurs who wished to build mills. Both Three Mile Brook and Hobbs Brook produced enough head to spin overshot water wheels. Abraham Bigelow operated lumber- and grist mills in 1735 at Stony Brook. In 1832, Nathaniel Sibley bought Bigelow's mills and then developed a nationally known hardware business that produced door locks, wood-planing machines, the Sibley dove-tailer, and the Sibley pencil sharpener. The site of the mills, now southwest of the intersection of Boston Post Road and Route 128/95, is pictured above. Another industrial site was on Crescent Street, a narrow street north of Route 20 that was part of the original Boston Post Road. The private homes at 39 and 49 Crescent Street are in front of the dams and millponds of Three Mile Brook, where waterwheels ground grain and small factories produced butter churns, clocks, school chairs and desks, and window screens. The foundations of the water wheels may still be seen.

Opposite, above: James T. Foote bottled cider and root beer in his store on North Avenue. Foote's products were but one of many produced in Weston. Red ware was produced in the pottery built by Abraham Hews Jr. at 651 Boston Post Road in 1765. His business continued to operate for more than a century, moving to Cambridge in 1871. Hews' house was the first post office.

Opposite, below: Weston regulated the sale of alcohol before Prohibition. Constables raided the drug store in Weston Center in 1906, seizing a small quantity of liquor. The owners were fined $250, and the drug store soon went out of business. Weston remains a dry town today. This photograph shows Cutting's store; no photographs of the drug store have been found.

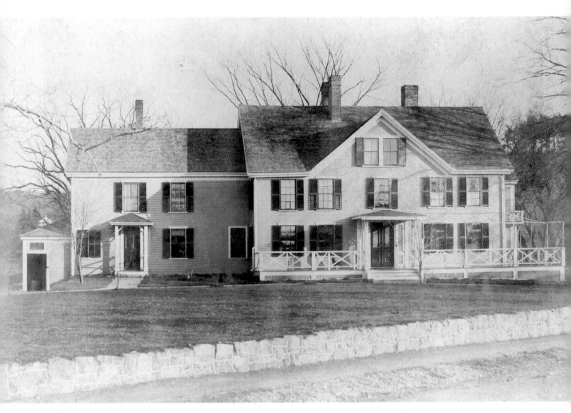

Above: The Hobbs Brook Tannery operated for more than a hundred years. Josiah Hobbs purchased 122 acres on North Avenue in 1729, and he built the house shown above and a tannery there in 1750. With the help of his sons, Hobbs turned the hides produced by Weston farmers into a ready supply of leather to be made into harnesses and shoes by Weston farmers during the winter months. In 1827, the farmers sewed 17,000 pairs of shoes and 5,600 pairs of boots to be shipped to Boston by the tannery. The family, in need of apprentices to keep the business going, signed a five-year contract in 1762 with Benjamin Brown, an apprentice from Lincoln. Brown was to keep Hobbs' secrets, obey, and refrain from fornication and matrimony. In turn, Hobbs promised Brown that he would teach him the tanning trade; feed and lodge him; keep his clothes clean; and teach him reading, writing, and cyphering. At the end of the five years, Brown would receive two good suits of apparel, one for Sunday and another for common use.

Opposite: The Hastings Organ Factory was built along the Fitchburg Railroad line in 1888. Francis Hastings (1836–1916) moved the 40-year-old business from Roxbury to the site of his parents' farm on North Avenue. Hastings, having recognized early that he would not enjoy the life of a farmer, left home to seek his fortune in Boston. He joined the Hook and Hastings firm and eventually become a partner in 1865. With the deaths of the Hook Brothers, Hastings inherited the business and began to carry out his dream of a utopian community of highly skilled workers, producing a quality product for the benefit of the owner and the workers. On Sunday, July 13, 1890, the Boston Herald recognized the success of his efforts by headlining their story on Kendal Green as follows: "A Community of Labor— An Object Lesson for Employers and Employed—The Labor Experiment at Kendal Green—Harmony of Relations Between Those Who Work and the Man Who Employs the Workers—A Community Like a Family."

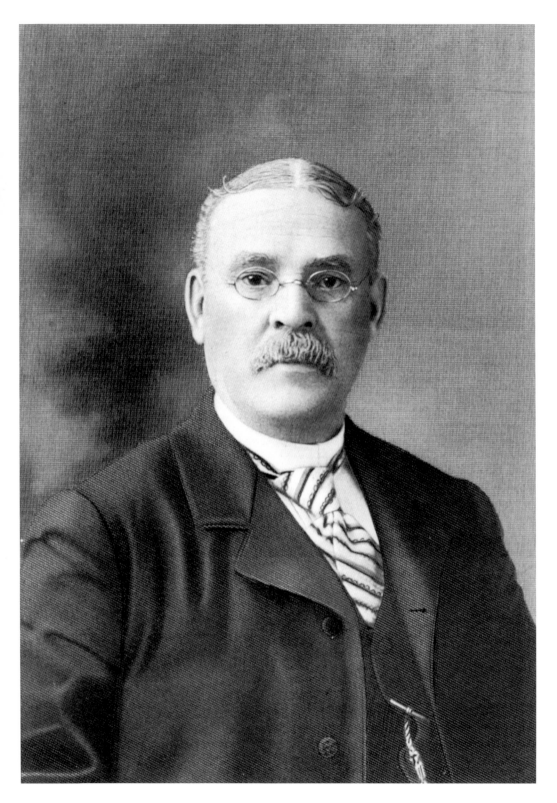

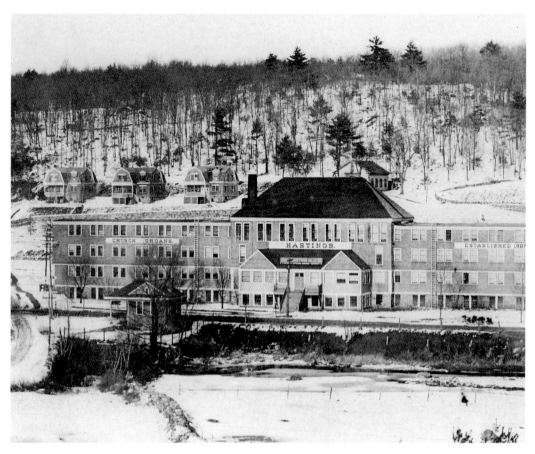

The Hastings Organ Factory had its own stop on the Fitchburg Division of the Boston and Maine Railroad. The factory could not have been constructed and operated without the railroad, which connected the operation to cities throughout the United States. Hastings was the train stop for many workers who commuted from Waltham and Boston to Weston daily in the early years of the factory. Each wing of the factory was 100 feet long, with three stories and a basement. The center section was 80 feet long and 40 feet high, enabling organs to be assembled, tested, and played before being crated for shipment to their destinations. More than 2,500 organs were built by the company during its operation in Boston and Weston. Among the notable churches that Hastings constructed organs for were the Trinity Episcopal Church in San Francisco and St. Paul's Cathedral in Boston. Note the three houses for workers to the left behind the factory and the one-room Northeast District Schoolhouse directly behind the assembly room. All children of the factory workers who lived in Weston attended the school.

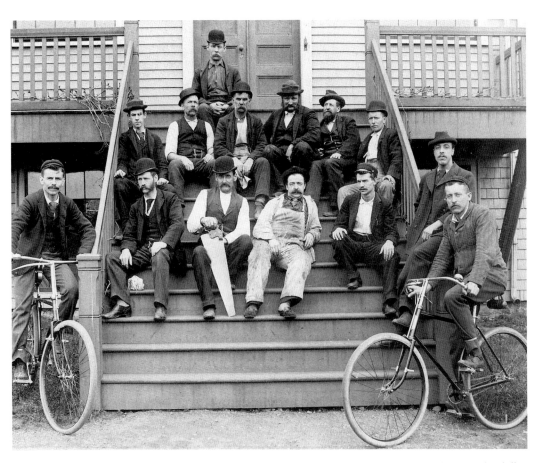

Some of the employees of the factory gathered on its steps to be photographed around 1900. The skills needed to carry on the business were varied. Among the employees who signed a oath of loyalty to Hastings in 1906 were a salesman, a tuner, a foreman, "a road man on installation," a mill foreman, a cabinetmaker, a maintenance man, a pipemaker, and a draftsman. Carroll Berry, the mill foreman, is second from the left in the second row from the top step, in his shirt sleeves. Note the bicycles for transportation; one employee owned a "Columbia chainless" and another a "Waltham comet."
A number of descendants of organ factory employees still live in town.

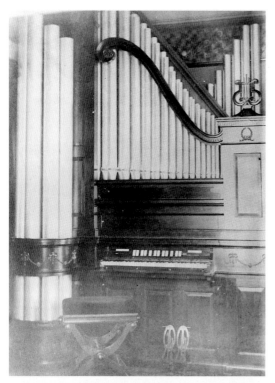

Left: Hastings was an inventive entrepreneur. In 1905, he drew the plans for an organ with 12 stops, which he installed in the music room of his house. A pianola player could be attached to the organ and would play rolls similar to those used in player pianos. Among the selections in his collection were "The Polonaise Militaire," "The Blue Danube," and "Tales from the Vienna Woods."

Below: Hastings employed European experts, and they trained American workers to produce the custom-made organs. Hastings' organs enjoyed a worldwide reputation, with orders coming from as far away as Philadelphia and San Francisco. John D. Rockefeller Jr. ordered a Hastings organ for the Riverside Church in New York City. This photograph of the wooden pipe room was used in a brochure that showed the entire process of constructing a Hastings organ.

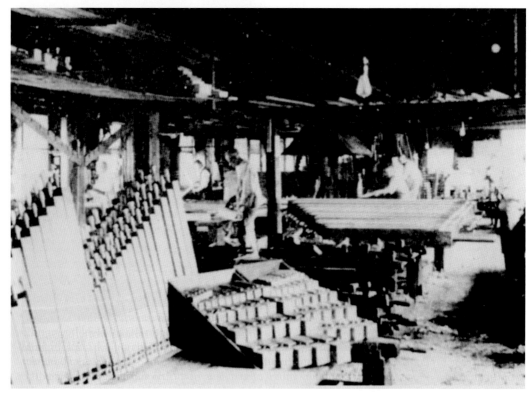

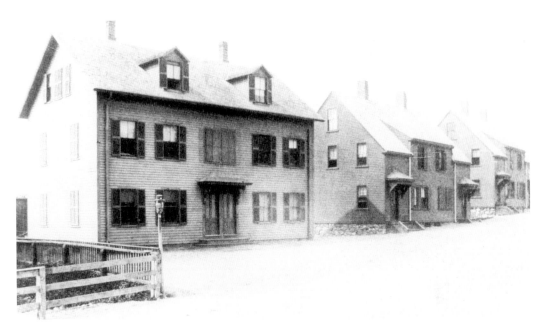

The Hastings factory was Weston's largest employer from 1887 until its closing. The town population was about 1,700 when Hastings built his factory, and he employed more than 70 skilled workers. Construction of housing for the factory workers created more jobs. The building on the left was a boardinghouse built on Viles Street for unmarried factory workers.

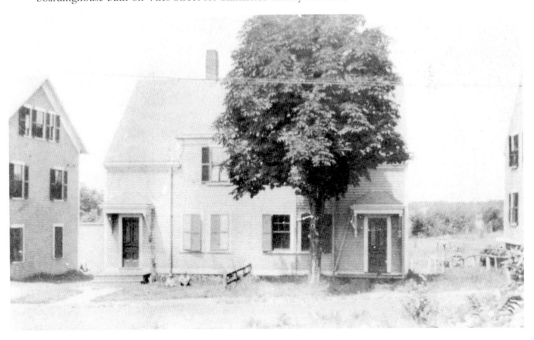

Hastings built cottages and rented them to his employees. Families of workers and supervisors often shared two-family houses, such as this one on Viles Street, built in 1897. Mr. Hastings prided himself on knowing all of his workers and their children. When he celebrated his 70th birthday in 1906, his employees gave him a party and presented him with an engraved testimonial signed by each of them.

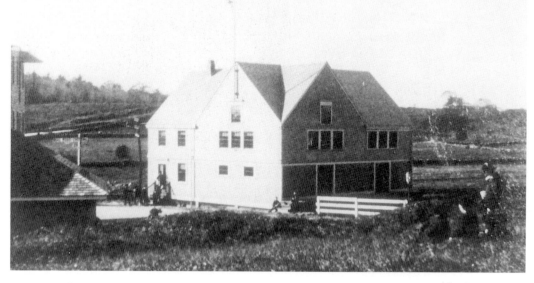

Hastings Hall (1891–1944) was a clubhouse with reading rooms and a large hall open to the public. Lectures, charades, dances, piano concerts, and suppers filled the calendar. Organs were assembled there, and free concerts were performed to test the organs before shipping. When the business celebrated the completion of its 2,000th organ in 1904 with a banquet and organ recital, more than 150 employees and their families attended the event.

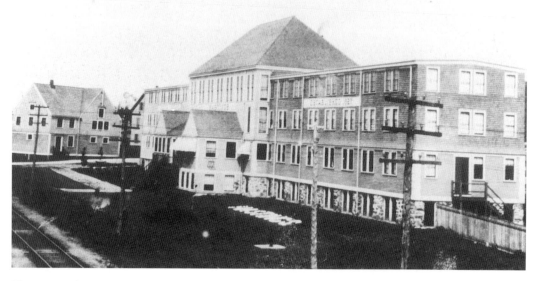

The Hastings business prospered, but not without difficulties. A decline in orders in 1906 led to layoffs for seven men. The following year, 35 men went on strike, demanding a Saturday half-holiday. The Depression and the decline in church construction ended the operation of the factory in 1935. The factory was demolished in 1936, leaving no trace of the large building.

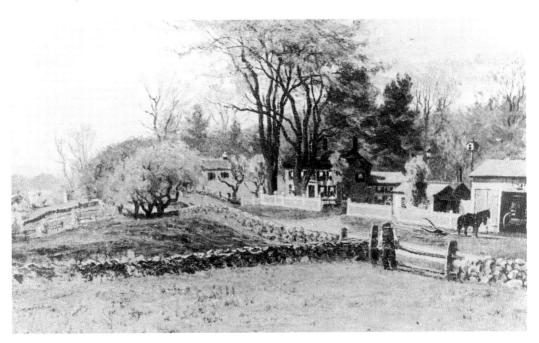

Hastings commissioned J.J. Enneking, a famous artist, to paint the nostalgic rural scene from the front yard of the estate he built on North Avenue in 1880. The painting shows the Hastings homestead, where he grew up, and the Northeast District Schoolhouse. Anna Hall, niece of Anna Coburn Hastings, donated the painting to the Weston Historical Society in her will. Hall lived to be 101.

Hastings built the fire station on North Avenue to have equipment available for volunteers to fight any fires at the organ factory or in the homes in the neighborhood. His interest in the town led him to compile a pictorial history of the old houses in town in 1894, and he also made numerous donations to the schools. He held only two elected town offices: Trustee of the Burial Grounds (1896–1898) and Field Driver (1899).

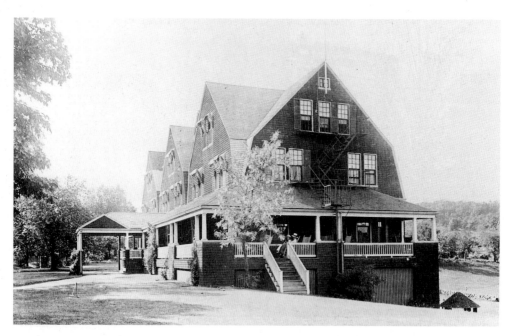

Opened on North Avenue in 1897, Drabbington Lodge welcomed visitors year round. Summer visitors coming from Pennsylvania, New York, and Boston frequently made the lodge their "permanent" summer residence. They were attracted in part by the golf course north of the lodge. Winter did not deter visitors. In January 1907, 41 guests arrived from Medford and Arlington by Tally-ho (a four-in-hand pleasure coach) and horseback for an evening of dinner and dancing.

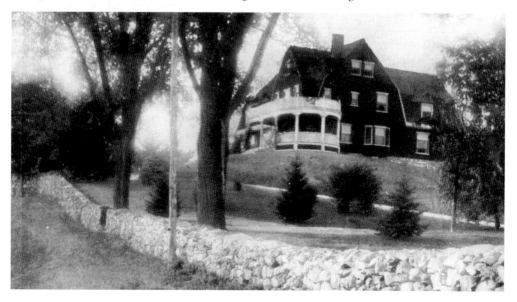

The Drabbington Lodge appeared on a postcard that was sent as a Christmas card. The card was postmarked at "5 PM, Dec 24 1903." Postage was a 1¢ stamp that had a portrait of Benjamin Franklin. A large drawing of the American eagle covered almost one-third of the postcard, which was addressed to "Miss Margaret Pratt, Weston, Massachusetts." Did Margaret receive the card in time for Christmas? We shall never know.

seven

Estates

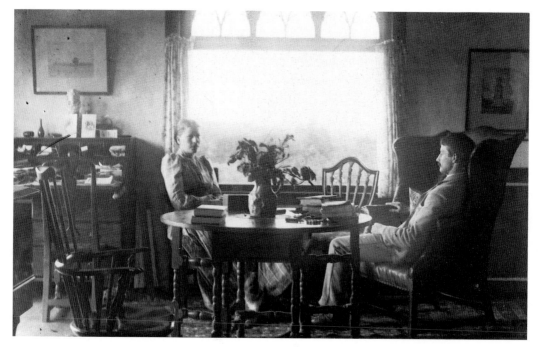

Mr. and Mrs. Samuel Mead enjoy the living room of their home at 59 Conant Road in 1894. Mead was a well-known architect. The Weston population was growing for different reasons: businessmen could commute into Boston on the frequent trains, the landscapes were lovely and healthy, and the tax rate was low. Note the large picture window overlooking the fields.

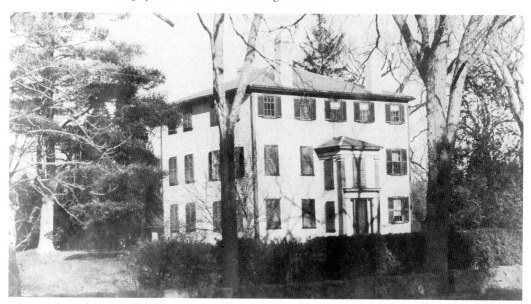

John Mark Gourgas, reputedly of a noble Huguenot family, purchased this house in 1822. The property is located on Boston Post Road, east of the town center. The house was listed as the most valuable property in town in the 1860s. Much larger homes were built in town after 1875 by wealthy Bostonians seeking the life of the gentlemen farmers. The property has been the home of the Gifford School since 1971.

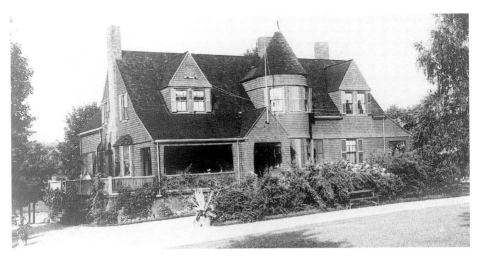

Francis Hastings built his home at 190 North Avenue in 1885. He commuted to Boston daily before moving his business to Weston four years later. Hastings sited the main part of his new organ factory just down the hill behind his home, where he could easily observe the operations. The design of Hastings' house, built with wood in the Victorian style, was typical of comfortable homes designed in this period for upper-income families.

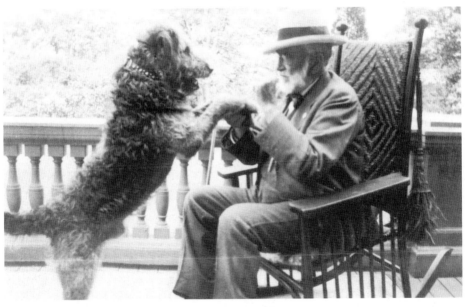

Charles A. Dean (1844–1921), shown here with his dog Buck, was a prosperous businessman. A native of Shrewsbury, Massachusetts, he ran away from home at 16 to serve in the Civil War. He survived three years of fighting, including the Battle of Vicksburg. Dean then sought his fortune in Cincinnati; there, he became a salesman for the Hollingsworth & Whitney Paper Company. Within seven years, he was president of the company and served in this position from 1872 until 1897. Oak Ridge, his estate, was located on Byron Road. Businessmen who needed to remain close to their city offices found Weston to be an ideal location. The railroad closest to the Dean property ran into South Station in Boston, only 12 miles away. The farms on the south side could be purchased at reasonable prices to create the large estates desired by the wealthy.

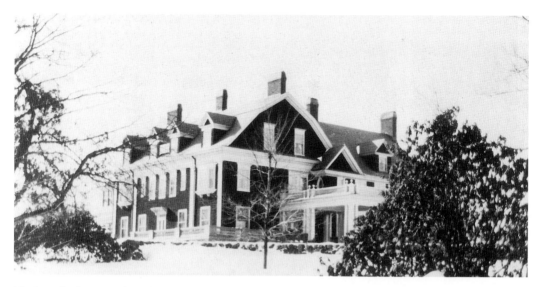

Mr. Dean built a magnificent home in Weston. Fourteen full-time employees maintained the house and gardens and farmed a portion of the property. His hunting and fishing camp in Kokadjo, Maine, just outside Greenville, was his favorite spot for a vacation. He donated $250,000 to build and endow a hospital and $150,000 to build a YMCA in Greenville. The timber, made into paper for his company, came from Maine forests.

A descendant of Dean labeled this photo: "Mr. Dean plays with his frog." Frog ponds, marble-lined pools, and elaborate gardens beautified all of the estates. Mr. Dean spent summers in Weston and winters on his yacht in Punta Gorda, Florida. With his wife, Minnie, and a crew of seven, he sailed to the Gulf of Mexico for fishing. Each crew member received a Christmas bonus of $2,500 in 1898.

The Japanese garden on the Dean estate offered the opportunity for quiet contemplation. Estate owners prided themselves on the beauty of their gardens and landscapes. They hired professional landscape architects to design the plantings and usually employed several gardeners to maintain the property. Miss Marian Case donated her estate and its extensive grounds, containing many exotic plants, to the Arnold Arboretum of Harvard University.

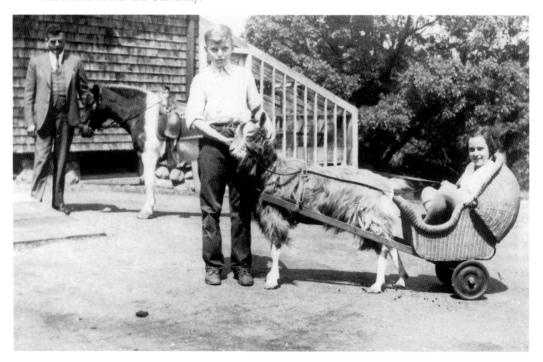

Fred Campbell and his cousin from Nova Scotia enjoyed driving Murphy, the pet goat, on the Dean estate. Campbell's grandfather and father both worked for the Deans and for the Byrons, who purchased the Dean estate. The staff and their families lived on the farm year-round, though Dean himself spent the winters in Florida. The estate was operated as a self-supporting farm.

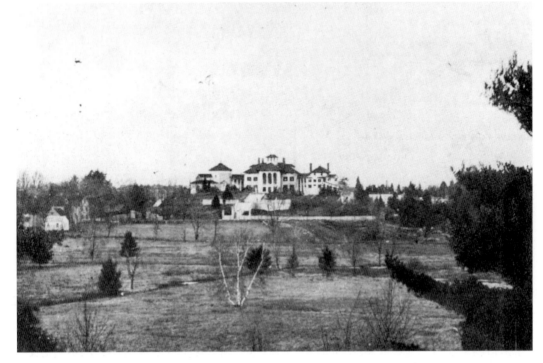

Above: Weston is known today for its beautiful trees. In the 1850s, only 10 percent of Weston was forested. Farmers had cleared the land for farming and for apple orchards. The use of trees for wood, fence posts, and fuel led to the steady decline of the forests. This photograph of the Horace Sears' estate illustrates the panoramic vistas that could be seen in town in 1900. Sears (1855–1923) ushered in the "estate era" in Weston. The son of Reverend Edmund Sears, minister of the First Parish, Sears made his fortune through his affiliation with the textile firm of N. Boynton Company. Many of his Boston friends moved to Weston after he built an estate east of the First Parish Church. He contributed a great deal to the community, making generous donations for town and church needs. By the time he was 28, he had already served three years on the School Committee. He wintered in Boston, summered in Cataumet, and spent the spring and fall in Weston.

Opposite, above: Horace Sears' gardens were immaculate. Pools reflected the tall windows of the house. Inside, a great marble staircase and a gold piano impressed his visitors. Sears left his estate to his partner, Harry Bailey, whose Italian wife made some alterations. She immediately replaced the marble staircase with one of wrought iron and replaced the leather wallpaper with plain stucco. In 1946, the property was razed, and the land was divided into eight large lots for new houses.

Opposite, below: Horace Sears welcomed all residents to events held in the theater at "Hialewa," his estate. The theater, seating more than 200 people, was used for many entertainments. Friendly Society productions were held there until 1919. Sears opened his bowling alleys to high school students for afternoon recreation.

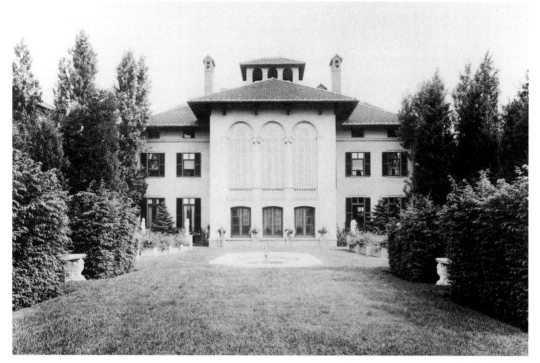

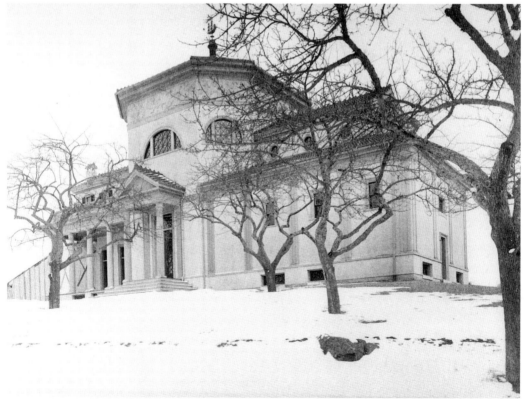

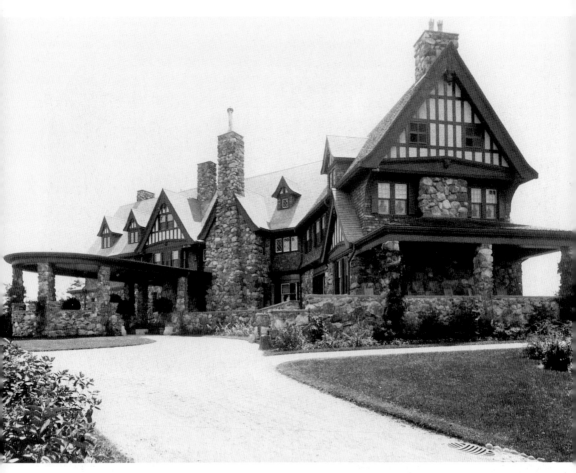

Above: The Edward R. Peirce house stood on the high point of an 85-acre estate on the Weston/Wellesley line. Peirce (1864–1951), a prominent Boston wool merchant, bought the estate in 1909. A writer in The Boston Sunday Herald Magazine described Weston in 1902 as "the Lenox of the East," praising the town for having all the elements that make a quiet and convenient country residence for a Boston businessman. The Tudor-style mansion was built in 1901 by E.H. Clapp, a rubber company president. It underwent $90,000 worth of renovations in 1910 under the guidance of architects from Sheply, Bulfinch, Richardson, and Abbott; the interior was completely remodeled and electrical wiring was added. Between 1915 and 1917, Mr. Peirce added 250 acres to the estate, along with a new garage that had a 15-foot turntable to turn the automobiles around at the top of the hill, a new greenhouse, a cottage, and a remodeled barn/recreation center. Fire struck in 1925, destroying the original house, which is pictured here. Damages were estimated at $250,000.

Opposite, above: The library of the Peirce house shows the results of the enlarging and remodeling of the house in 1910 at a cost of $91,000, an enormous expense. Peirce arranged the remodeling, which included installing extensive electrical wiring, replacing fireplace mantels and trims, and enlarging the size of the kitchen/service area.

Opposite, below: Mr. Peirce rebuilt the house after the 1925 fire, changing its facade. Roger Babson owned the estate from 1951 until 1960, and his daughter eventually sold the estate to a group of Wellesley businessmen, who subdivided the land. In 1961, Ernest Henderson, the president of the Sheraton Corporation, purchased the house for Northeastern University to use as a conference center. The house, known today as the Henderson house, was entered in The National Register of Historic Places in 1997.

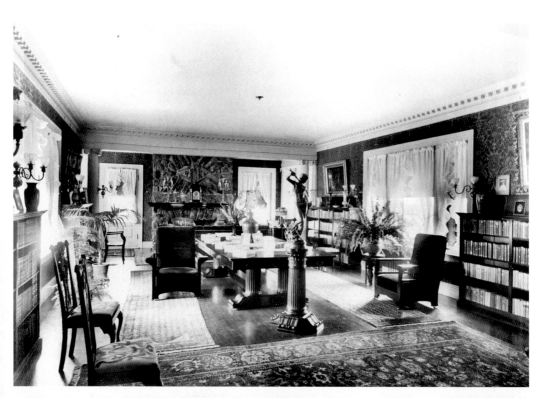

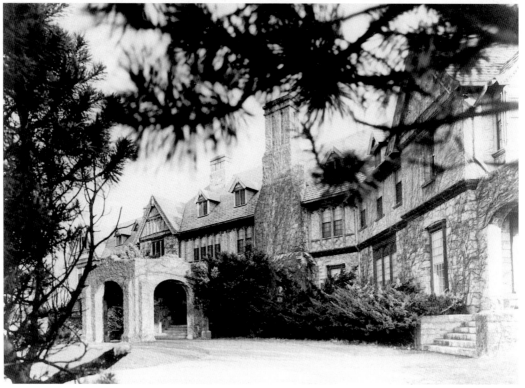

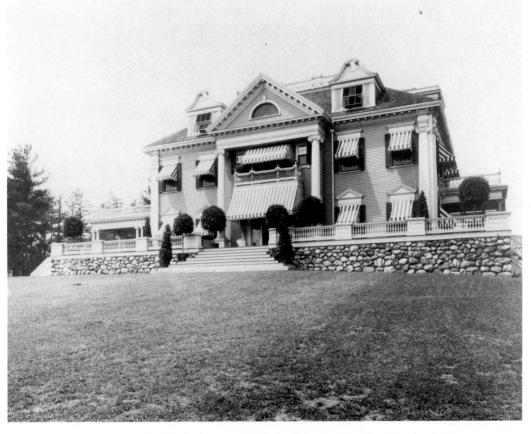

Mr. and Mrs. B.T. Morrison lived in the home on Wellesley Street built by Mrs. Morrison's father, Daniel Demmon. Mr. Demmon's wealth came from investments in copper, coal, railroads, and Boston real estate. Mr. Morrison was president of the Reading Rubber Company. From the house, facing directly to the east, one could see downtown Boston and the Statehouse dome. The original clapboard siding shown here was replaced by a brick facade in 1914, creating a more formal house that reflected Georgian style. The Morrisons traveled frequently, purchasing interesting souvenirs. Mr. Morrison returned from France in 1911 with a $12,000 Renault and a new chauffeur. Mrs. Morrison returned from their trip around the world in 1912 with two small Japanese dogs and ten India birds. Following the death of her husband in 1921, she moved to their home in Pasadena, California, and, in 1927, sold the estate to the Sisters of Saint Joseph for $225,000. The Sisters modified the house and opened Regis College to a class of 55 students. Today, the Morrison house is the home of the college president.

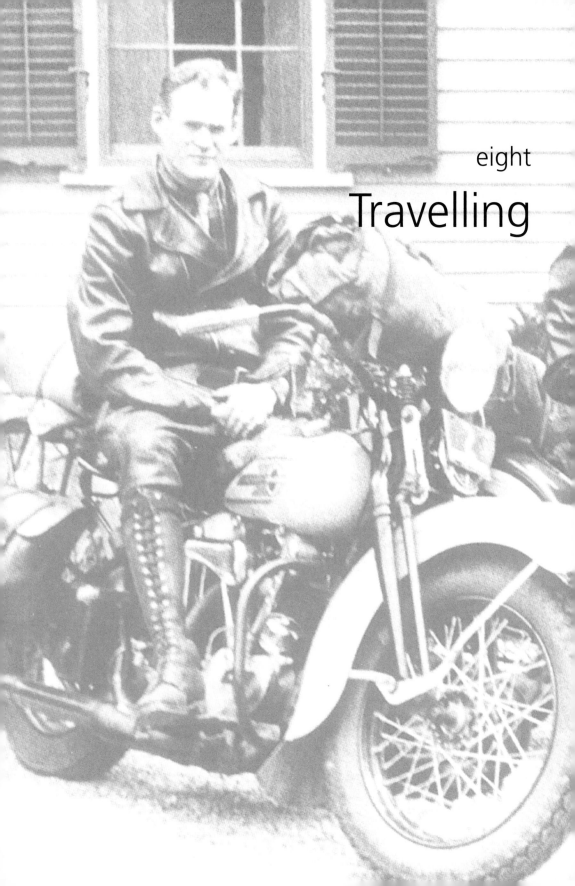

eight

Travelling

In 1959, Pine Street was still a narrow country lane, typical of roads built for carriages and horseback riders. The condition of the roads was a subject of continual concern. In 1870, an Ashland resident threatened to sue the town after breaking his sleigh on the main road from Weston to Ashland. He had been forced to pay $3.75 for repairs because the road had not been "broken out."

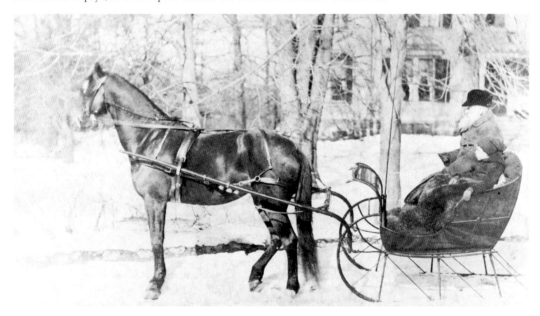

Winter brought the pleasure of sleigh rides. Avoiding the mud of the spring and the dust of the summer, some early residents preferred to travel by sleigh, protected by a buffalo robe. Party-goers might travel by sleigh or pung as far as Sudbury on a winter's day, stopping along the way for hot chocolate. Younger people enjoyed sledding down the big hill on South Avenue, over half a mile, to Ware Street.

In the 19th century, a vehicle known as a "pung" took children to school during the winter months. The pung was a cross between a wagon and a sleigh. The large pungs—which might carry as many as 20 children—had a thick layer of hay or straw on the bed of the pung and a buffalo robe to protect the children from the cold.

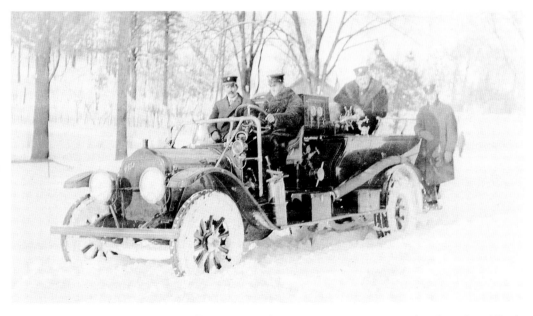

Winter weather slowed down traffic. Members of the Weston Fire Department found traveling difficult during a 1914 snowstorm. Many town residents who owned horses continued to keep their sleighs ready to cope with snow. Following the Blizzard of 1920, commuters relied on sleighs to take them to the trains for six weeks. Roads would be rolled to compact the snow, making an excellent surface for sleighing.

Miss Florence Coburn and her friends celebrated her birthday in 1911 by visiting Mt. Wachusett, more than 50 miles west of Weston. Mt. Wachusett is the highest hill in eastern Massachusetts; a hotel built at its summit offered refreshments for visitors who drove to thetop. P.J. McAuliffe, chief of police and owner of the Weston livery service, took the girls. He owned several fine automobiles: a Cadillac, an Overland, and a seven-passenger Pope-Hartford.

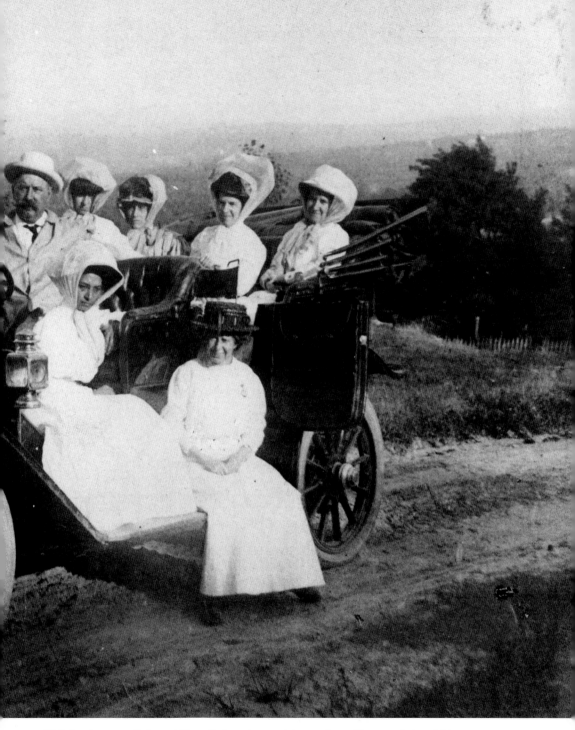

"P.J.," as he was called, could be relied on day or night to take residents to their neighbors, to Boston, or to nearby communities. Given the condition of roads and the number of flat tires on any extended automobile trip, the many excursions taken by Weston residents were remarkable. Although railroads provided the transportation for daily commuters, the automobile offered the freedom and mobility that is still prized today.

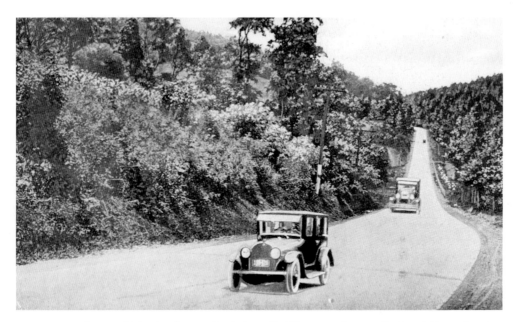

Weston was a favorite destination for vacationers as well. This postcard was mailed in 1929 to a friend in Danvers, Massachusetts. The writer had spent the month of August in "a lovely bungalow" in Weston and three weeks of July at the beach. The owner of the postcard believes that the scene is of South Avenue, an area considerably less developed than the other parts of town in 1929.

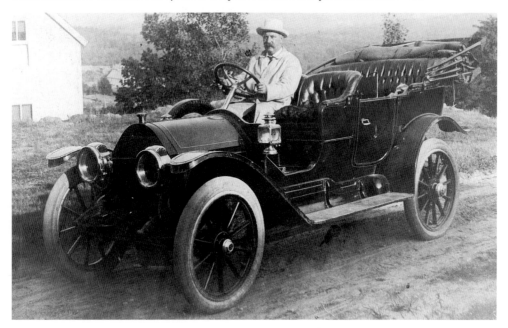

Automobiles, and how to control them, continued to worry townspeople. One resident counted 800 automobiles passing by on Boston Post Road (then Central Avenue) on a summer Sunday in 1909. By 1912, town regulations required drivers to blow their horns at street corners. Shown above is P.J. McAuliffe, the chief of police, who was known as far away as Framingham for his efforts to enforce local traffic laws.

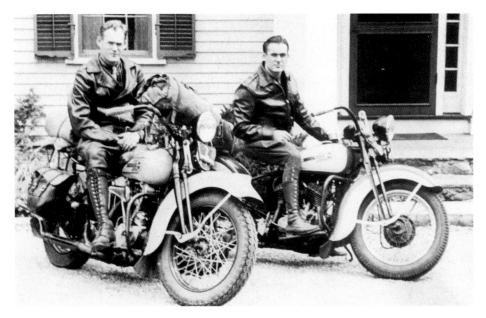

Weston residents traveled across the United States as well as to Europe. Grant Dowse, on his 1937 Harley Davidson motorcycle to the left, rode more than 5,050 miles to New Orleans and back in 1939, with only one engine needing to be rebuilt during the trip. He has owned 22 motorcycles and continues to ride his motorcycle around town to collect contributions to Project Bread, an organization that provides food for the homeless in Boston.

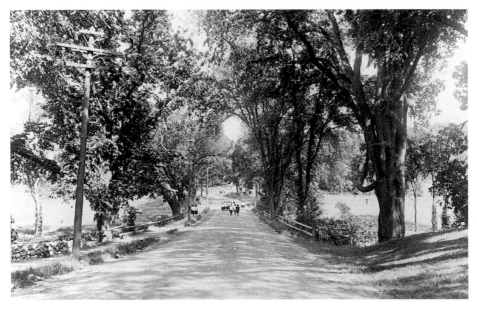

North Avenue, the main road through the northern part of town, connected Waltham to the east with New Hampshire and Vermont toward the northwest. In the early 19th century, farmers living west of town herded cows, pigs, and chickens along the road to Boston markets. The lovely elms in this photograph from the turn of the century fell victim to the ravages of Dutch Elm disease.

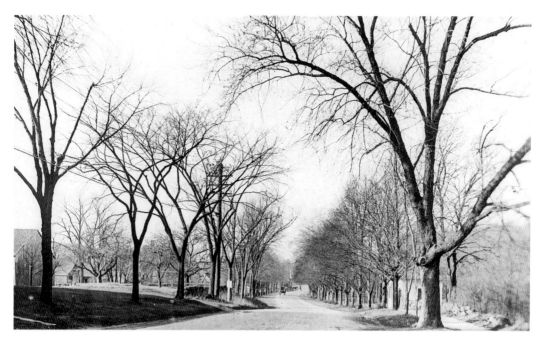

Town meetings between 1899 and 1912 considered many issues. Should Boston Post Road become a state highway? Should the speed limit for automobiles be 15 miles per hour? Could the town keep certain roads free from automobiles altogether? Quiet streets through the center of town, such as this view of Boston Post Road that looks west from the Josiah Smith Tavern, would soon be a memory of the past.

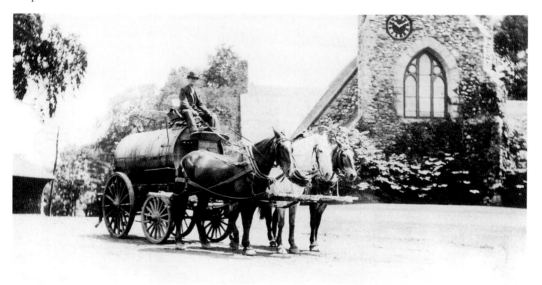

In the early days of automobile travel, drivers going from Boston to New York followed the main route through Brookline, Newton, and Newton Street in Weston on their way to Worcester. This water wagon, pictured in 1914, was used to keep down the dust on the crushed stone roads.

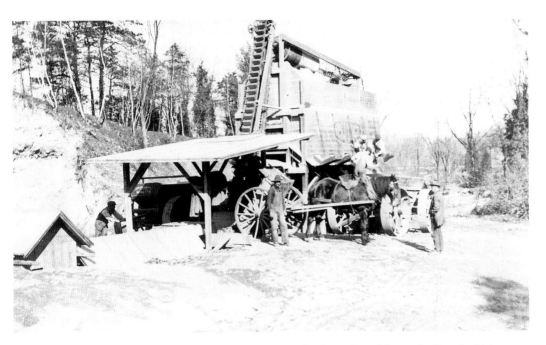

The crusher at Kendal Green was used to prepare stone for the surface of the roads. Costs for highway construction and repair made up a substantial portion of the expenditures in the town budget at the turn of the century. The stone was shipped into town on the Boston and Maine Railroad. Residents near the busy line complained that train whistles annoyed them day and night.

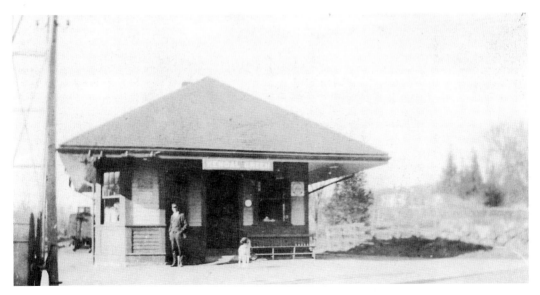

Kendal Green station, on the Fitchburg Line, was one of six train stations in Weston in 1900. Three railroad lines with a total of 8 miles of track crossed the town east to west. Commuter trains carried residents to Boston, while freight trains carried raw materials and goods both ways. The Stony Brook station shipped 362 tons of freight during one week in 1906. This station has since been converted into a private residence.

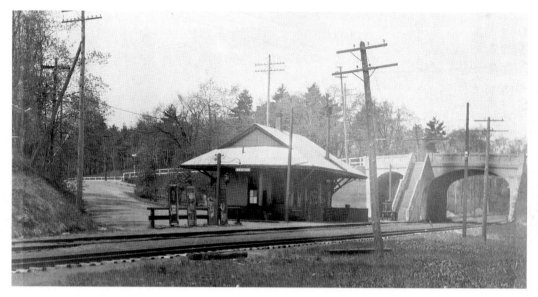

The Weston train station, a convenient stop for residents living near the center, still stands by Church Street. The Massachusetts Central Railroad between Boston, Wayland, and Northampton was finally completed in 1887, after 15 years of construction. It eventually ran 12 trains a day in each direction. The last train ran in 1971. Voters at a 1997 town meeting rejected a proposal to make the right-of-way a "rail trail" for public use.

The bridge over the Charles River where South Avenue and Commonwealth Avenue meet was constructed of stone on the Newton side and wood on the Weston half. When the Weston side needed to be replaced, town voters seriously debated how much to spend. They finally decided to match the Newton half and built a stone bridge in 1889. The bridge was razed as part of the construction of Route 128.

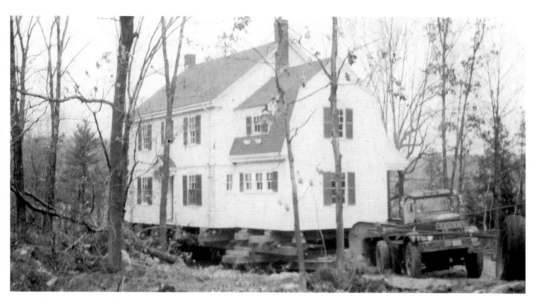

Construction of the Massachusetts Turnpike through Weston required the removal of many homes. This house was jacked onto blocks in 1956 and moved to a new location on Ridgeway Road. With the late-1960s completion of the turnpike extension into Boston, the town became a mecca for physicians, lawyers, and university professors who could commute to downtown Boston within 15 minutes.

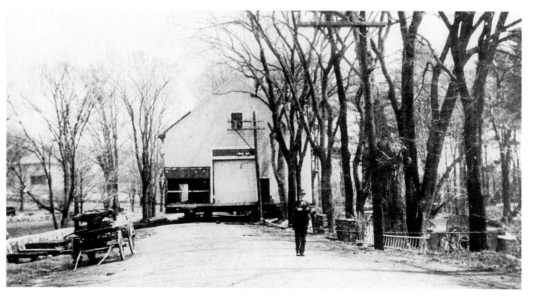

Owners moved houses and barns in Weston to more convenient or profitable locations. This barn, originally belonging to Isaac Fiske (who lived in Weston in the early 1800s), was moved 600 feet down Boston Post Road in 1920 to its present location west of the Farmers' Burying Ground. The barn was then remodeled into shops and office space. When Isaac Jones constructed the Golden Ball Tavern, he made certain that the west wing could be moved and become a free-standing house. In his will, he specified that his unmarried daughters would have the right to move the wing to create their own home "in case they did not get along with their brother." The brother was to inherit the property.

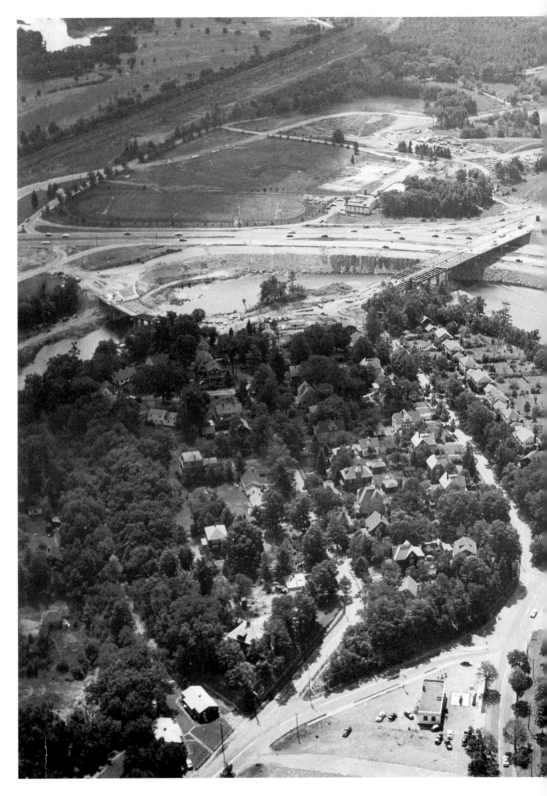

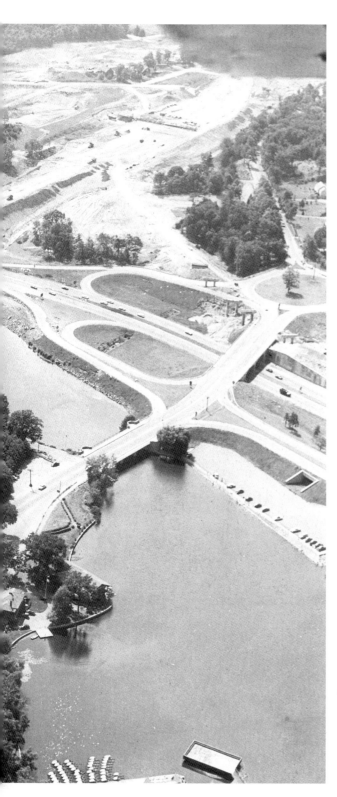

The construction of the interchange of the the Massachusetts Turnpike and Route 128 made a dramatic change in the southeastern portion of Weston. The bridge over the Charles River, in the upper part of the photo, carries the turnpike into Boston. The bridge on the right carries South Avenue into Weston (upper portion of the photograph), and leads Commonwealth Avenue into Newton to the east. The canoe rental, located in the bottom right, continues to offer canoes for recreation on the river. Trees and plants now cover much of the Weston area, although it is treeless in this photo from the mid-1960s. The interchange continues to be one of the busiest in Massachusetts.

The great Hurricane of 1938 struck Weston without warning. Travel was disrupted for days with many large trees down across roads and driveways. Particularly affected were the large pine trees that had reached maturity since the middle of the 19th century. They created much work to be done. Members of the Civilian Conservation Corps came to town to provide assistance to the many volunteers and local landowners.

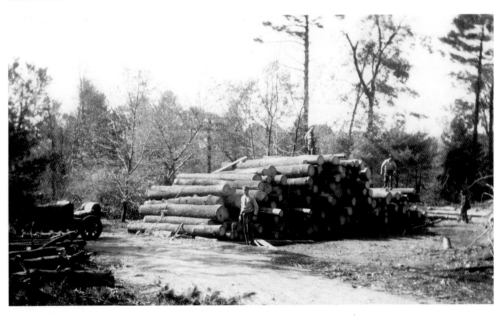

Many special plantings, introduced by landscape designers who created the grounds of the large estates, were lost during the hurricane. The Case sisters' estates lost 2,500 pine trees, 500 oaks, 250 maples, 74 apple trees, and 29 other fruit trees. Weston trees were hauled to sawmills in Wayland and 130,000 board feet of lumber were cut. Canadian woodsmen helped with the cleanup operations, which lasted over a year.

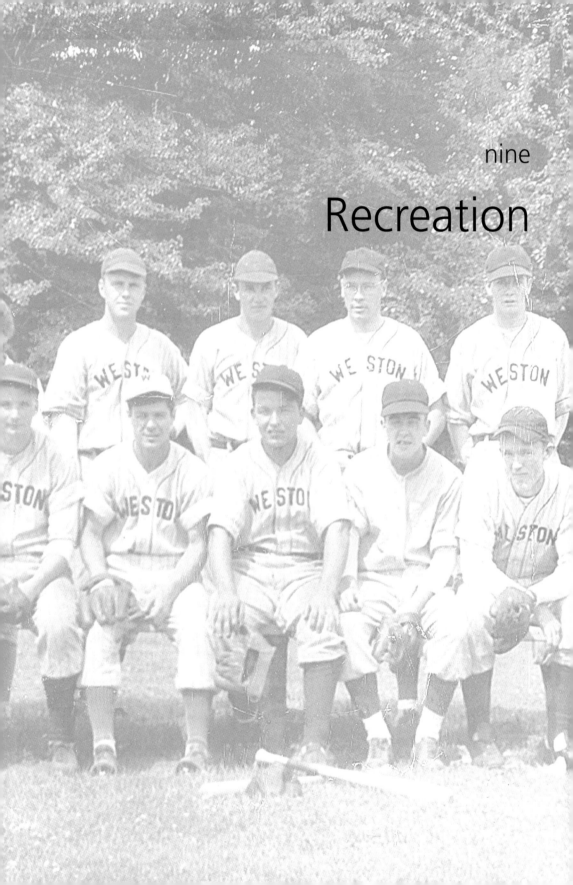

nine

Recreation

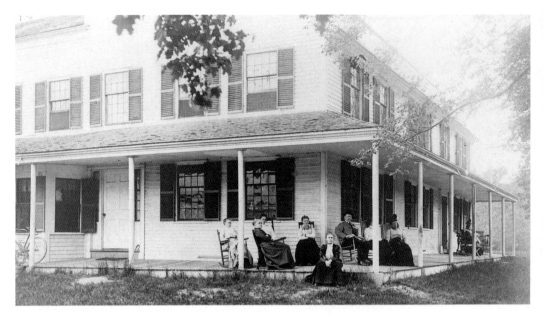

A favorite summer pastime was rocking on the porch. Here, Miss Alice Jones sits on the edge of her porch. Her home, formerly operated as the Josiah Smith Tavern, passed to the Society for the Preservation of Antiquities upon the death of her sister Ellen in 1950. The bustle of activities at Cutting's General Store and the Town Hall across the street seem far away in this photograph from 1900.

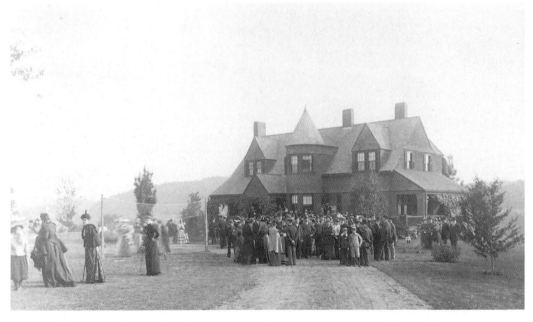

Weston residents enjoyed a number of outdoor sports. Francis and Anna Coburn Hastings hosted an open house at their home on North Avenue during the Northeast District School reunion in 1893. Note the net set up for play in the front yard. Women frequently played tennis and golf in long skirts.

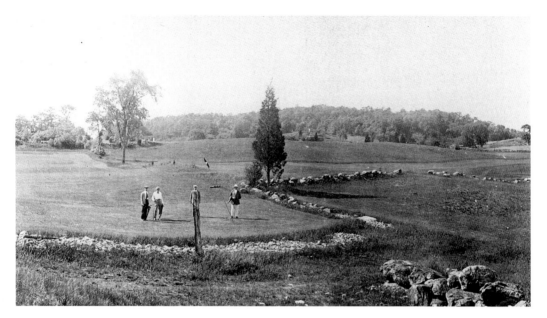

The Weston Golf Club, founded in 1894, built nine holes across the fields and along the woods and railroad tracks west of the curve on Church Street. Cows were pastured on the long third fairway, requiring the caddies to drive animals out of the golfers' way. Enthusiastic golfers wished to play golf on Sundays, but Arthur Coburn, owner of most of the land, refused. He believed that Sunday was a day for worship.

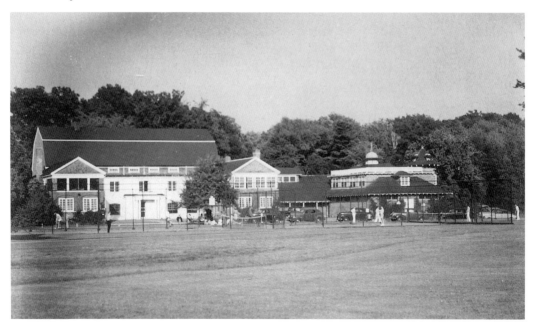

Robert Winsor offered 50 acres of his land for a new course and his barn for the clubhouse in 1917. Golf could now be played on Sundays. When two residents were arrested for playing golf one Sunday in 1894, the Waltham Free Press reported that the golfers sought "to break down the barriers . . . between the morality of a typical New England township and the immorality of France."

The Friendly Society presented plays to benefit the charitable activities of the First Parish Church. Weston residents took the roles and made up the majority of the audience. Horace Sears, estate owner and town benefactor, is standing to the left in the back row. Miss Alice Jones, at the far right, and Miss Ellen Jones, seated, lived in the Josiah Smith Tavern. The 1887 play was presented in the theater on the Sears estate.

The Friendly Society offers entertainment, charity, and social activities for town residents. The "Red Mill," an operetta, was performed in the new Town Hall's upper hall in 1919. The large cast enjoyed rehearsing and performing. Attending picnics after rehearsals at Nolte's Field on Highland Street, they could view the sunsets and Mt. Wachusett and Mt. Monadanock. The Friendly Society continues to offer two productions a year for the enjoyment of the town.

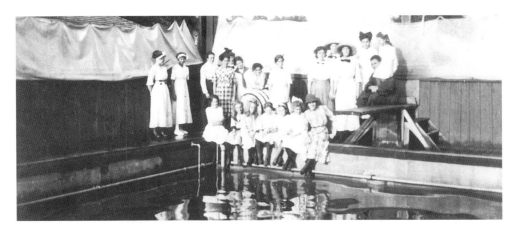

The old swimming pool, at the northeast corner of School Street and the Boston Post Road By-Pass, offered welcome relief from summer heat. Girls and boys swam during different hours. To increase interest in swimming, the manager staged a mid-summer water carnival in 1912, with prizes for the winning swimmers. To encourage the girls, the manager modified the rules to allow their use of the pool on Saturday mornings.

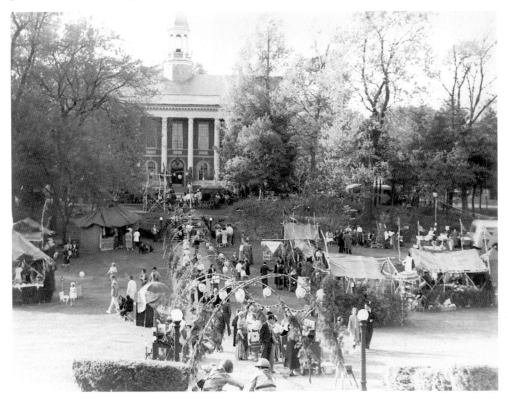

High school graduation ceremonies, concerts, square dances, and arts and crafts shows take place on the Town Green. The Women's Community League sponsored the Weston Street Fair shown here to benefit their Scholarship and Welfare Fund. The white banner in the center of the photograph advertised cigarettes for sale. An accordionist, a violinist, and "gypsy singers" entertained the crowd. The publicity for the event noted that "rain or shine, the fair goes on."

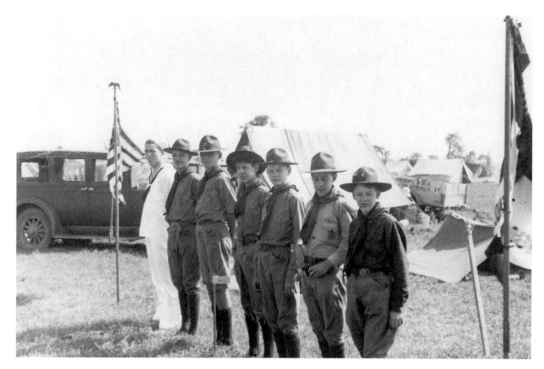

Above: Scouting offered many opportunities for boys and girls. The boys from Weston Troop Algonquin Council I are lined up here for inspection during their trip to Moose Park in St. John's, Quebec, for the June 1935 Scout Jamboree. The Girl Scouts also traveled to pursue their interests. In the early 1960s, the Sea Scouts sailed a schooner from Newport Harbor in Rhode Island.

Left: The Boy Scouts built a signal tower during their encampment on the Town Green on July 3, 1938. They demonstrated their skills using lines and tree limbs to build the tower. Note the improvised ladder that allowed access to the top of the tower.

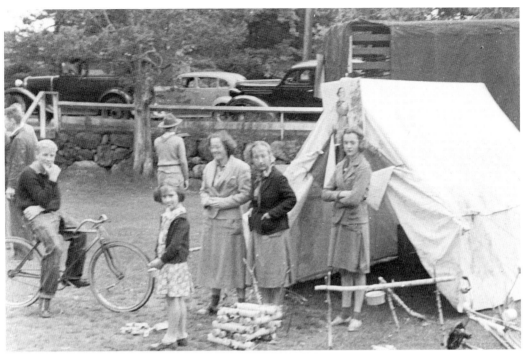

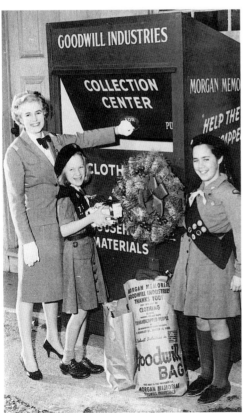

Above: While the Boy Scouts built their tower, the Girl Scouts set up the first-aid tent on the Town Green for the Fourth of July ceremonies in 1938. The informality of events on the Green continues to the present day. Each May, the Weston High School Student Council sponsors a "Spring Fling" for the younger children. Pony rides, games, face painting, and bouncing on the "moon walk" entertain the youngsters.

Left: The Weston Girl Scouts sponsored the Good Will collection box at the Kendal Station on the Boston and Maine Railroad Line in 1965. Mrs. Howard Anderson, Heather Saunders, and Patty Melone, all from Troop 763 of the Bay Path Colonial Girl Scout Council, set up the first of 431 boxes the charity planned to establish in the greater Boston area. The girls suggested the Christmas wreath to decorate the box.

Weston today has substantial land devoted to conservation. At the turn of the century, the many wooded areas and ponds delighted the boys of the town. Brown's Pond, shown above, was on the north side of North Avenue, in the village of Kendal Green. Philip Coburn visited the pond as a young boy, stopping on the way at Broderick's store and post office to buy a 5¢ bottle of soda on his way to fish. When he was 13, he began trapping muskrats and skunks. He and his pals took the furs to Boston to sell, where they received $1 per skin for muskrats and $2.75 for skunks. The pelt of one skunk brought $4.25 because it was mostly black with long prime fur. Bird watching was another popular activity. Warren Eaton recorded the birds he saw and helped Coburn find some pheasant eggs, which the boy raised to maturity. An early conservationist, Coburn released ten hens to their natural habitat when their coop became too small.

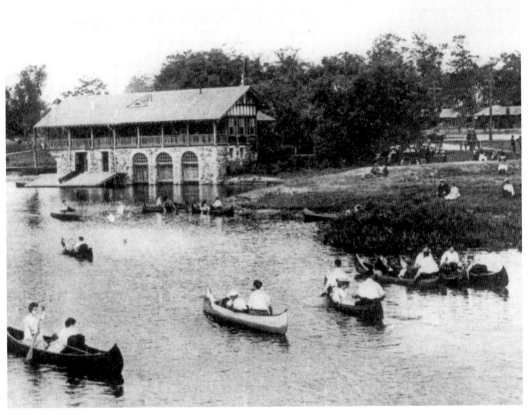

The Charles River offered excellent recreational opportunities but also dangers. One pair of friends, planning a long day's paddle on the Fourth of July in 1912, attempted to sleep in their canoe overnight. Their plans led to disaster when one of the boys suddenly awoke with a start, lurched to one side, and rolled out of the canoe to his death. His friend, who was able to swim, was saved by the police from the Metropolitan Park station. On a brighter note, canoes were available for rent at very reasonable rates, and many people took advantage of the opportunity to enjoy the river. Activity on the Charles increased when Norumbega Park opened. Built on the Newton side of the River, where the Marriott Hotel now stands, the park operated from 1897 until 1967, combining amusement rides, entertainment on a large stage, a zoo, and canoe rentals. The most famous feature of the park, the "Totem Pole" ballroom, opened in 1930. The ballroom featured every famous swing band, and was the location of performances by Frank Sinatra, Tony Bennett, and Dinah Shore.

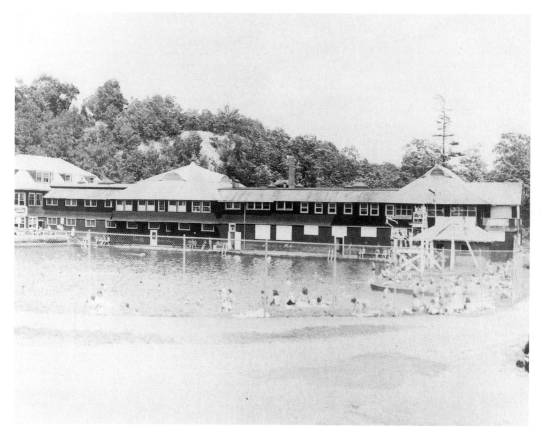

The Riverside Recreation Grounds, affectionately known as "the Rec," were constructed by Weston resident Charles Hubbard in 1897 to provide "city young people a place to get out in the country for exercise and pleasure." Hubbard's plans for the facility included two boathouses with canoes to rent, a restaurant and dance hall above the boathouses, a big swimming pool, and several free tennis courts and picnic areas. A footbridge was built over the Charles River to the Riverside station in Newton to facilitate access to the grounds from Boston and other towns on the Green Line. Twenty years later, he donated the buildings and 40 acres of land to the Metropolitan District Commission. The MDC operated Riverside through the summer of 1958. The U-shaped building around the pool and the adjacent boathouse were destroyed by fire in May 1959.

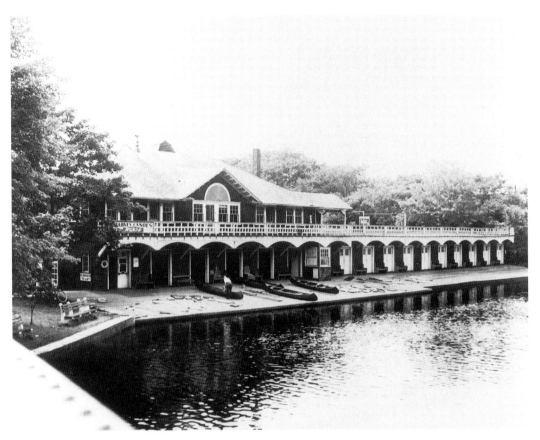

In the 1920s, the Riverside canoe livery was one of the three largest canoe rental facilities in the United States. The livery was located on the west side of the Charles River, where the Leo J. Martin golf course is today. The other two liveries were Robertson's boathouse (located directly across the river), and Norumbega Park, a half-mile down river. The boathouses suffered severe damage in the 1938 hurricane and were never rebuilt. The 1902 song, "Down by the Riverside," was written about this popular recreational facility. Thousands of canoes could be found on the Charles River between Newton, Weston, and Waltham. It was said that a person could walk across the river, stepping from canoe to canoe, on warm Saturday nights. Band concerts, performed on the river bank and attended by people in canoes, were popular entertainments during the summer months.

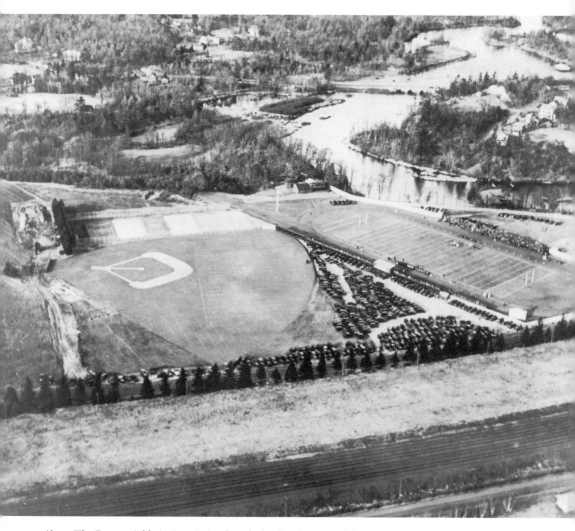

Above: The Boston Athletic Association bought land at the turn of the century and created a large recreational area north of the Boston & Albany railroad tracks in southeastern Weston. The Charles River flows through the upper right portion of the photograph. The Riverside Recreation Area was located south of this area. The land and buildings were purchased by Boston University in 1930 and became the school's principal athletic facility until 1952. This photograph dates from the period in which Boston University owned the land. The facility was called Nickerson Field. The school's home games for baseball and football were played here. The football players lived in dorms on-site, traveling by train from Riverside to Boston to attend classes. The site is now occupied by the Riverside Office Park and the interchange of the Massachusetts Turnpike and Route 128/95.

Opposite, above: Weston had a semi-professional baseball team from 1946 through 1950. They played teams from Lincoln, Waltham, Concord, Lexington, Maynard, and Newton, including the Newton Colored Giants, an African-American team based in the Myrtle Street area of West Newton. Teams disbanded when television began to offer alternative entertainment, and players found themselves busy with their young families. Joseph Sheehan, manager, and Mrs. Proctor, scorekeeper, are at the left end of the back row.

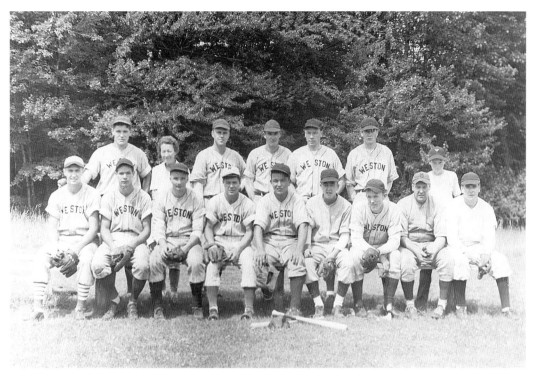

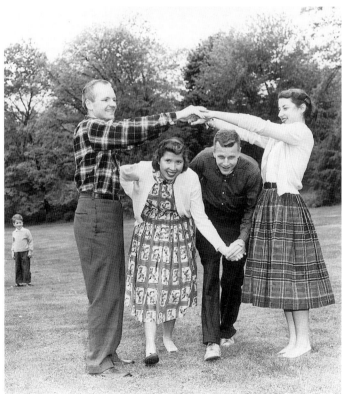

Left: Square dances on the Town Green provided entertainment for all ages. The American Legion sponsored dances from 1934 until World War II. Legion dances took place on a large wooden platform to facilitate the dancing. When the dances returned in the 1960s, participants trod the grass to their favorite tunes. The Recreation Department continues to sponsor early evening summer concerts on the Green, with music ranging from folk to rock.

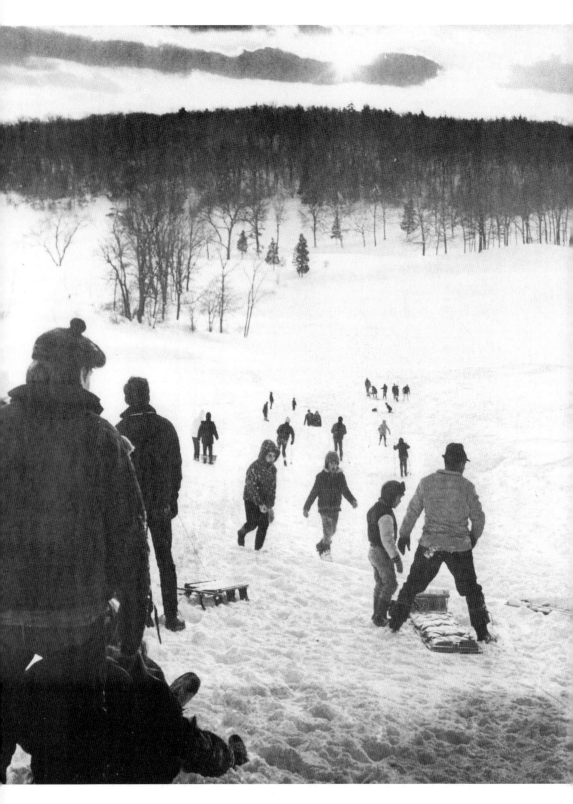

Cat Rock, north of Drabbington Way in the northeast corner of the town, was the center for winter fun. Snowshoers and skiers were making tracks, jumping off the rocks, and spraining their knees there as early as 1910. Cat Rock Ski Area operated on weekends in the 1950s and '60s with one open slope and one narrow trail. All of the grooming was done by hand. A rope tow pulled skiers up the hill. The base lodge was a small, tin warming hut with a stove inside. Lift tickets cost one dollar, and one enthusiastic skier managed to make one hundred runs one winter day.

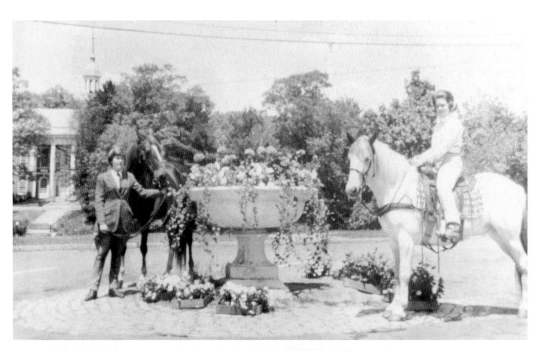

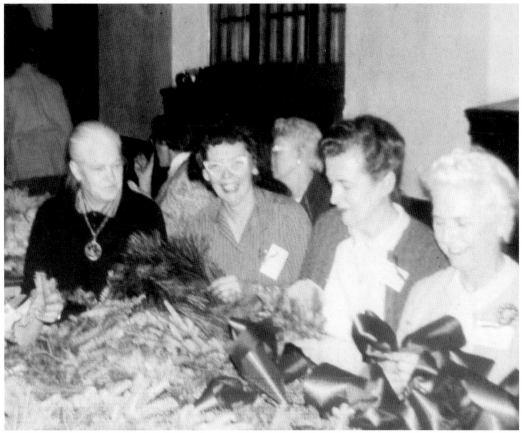

Above: Whether driving a buggy or foxhunting, townspeople have enjoyed owning and caring for horses. Here Stephen Carter takes Jane Cameron for a ride in his buggy pulled by a Shetland pony named Chocolate Chip. Both children are wearing the appropriate driving gear for the mid-1960s. This photograph was taken as a publicity photo for the 1747 Horse Show, an annual event continuing until a few years ago. At the turn of the century, foxhunting was popular in town. The Middlesex Hunt Club followed two foxes through the camp woods for three hours one afternoon in 1909. The first fox was drawn to cover after 2 1/2 hours, and the second was run into a hole after one hour for the "best run of the season."

Opposite, above: Members of The Weston Garden Club, founded in 1941, plant and maintain the lovely flowers and greens in the antique watering trough in Weston Center. The Country Garden Club maintains the herb garden at the Golden Ball Tavern, and the Women's Community League Garden Club cares for the flowers and plants at the barn at the Josiah Smith Tavern.

Opposite, below: The Weston Garden Club meets annually to create wreaths for public buildings in the town. The wreaths decorate Town Hall and the Josiah Smith Tavern. This group, meeting in the First Parish Church in 1962, is tying ribbons on the wreaths. Volunteer organizations continue to answer many of the needs of the community.

Residents continue to enjoy riding horses. The members of the Jericho Pony Club, shown here during a competition in Maine, learn the art of good riding from a young age. Many of them continue to ride as adults, and at least one has become a veterinarian. Weston has always enjoyed large areas of undeveloped land for horseback riding and walking. In 1900, the town had more than 5.5 acres of undeveloped land for every man, woman, and child in town. The selectmen and other residents petitioned the Metropolitan Park Commission in 1899 to establish a park at "Devil's Den" with its 18 acres of land near the Stony Brook Station, "one of the most picturesque and attractive places in town." While the commission took the matter under advisement, private negotiations continued and concluded with the opening of Massachusetts Broken Stone, a gravel pit, on the site.

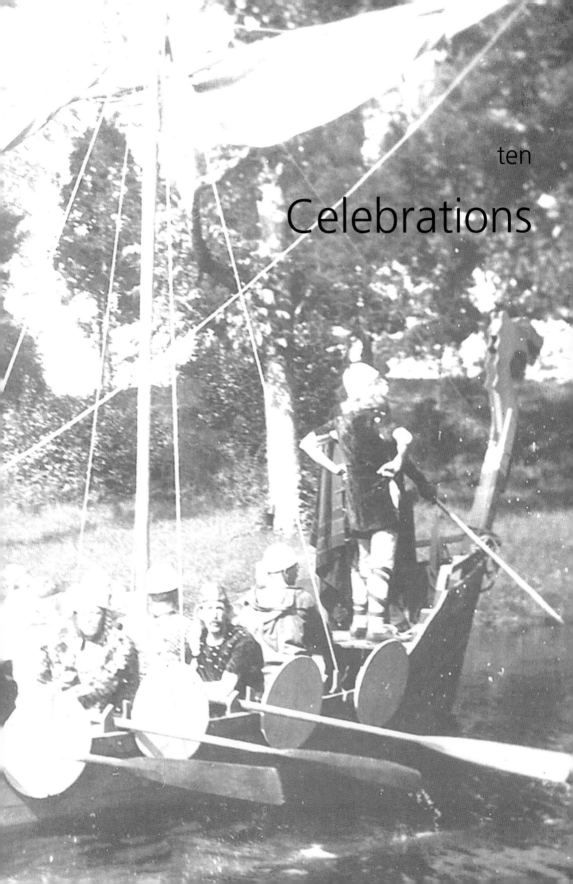

ten

Celebrations

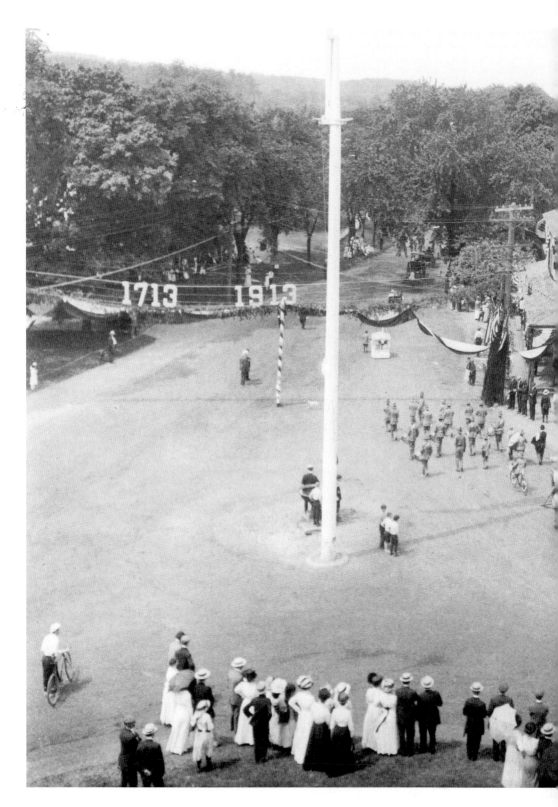

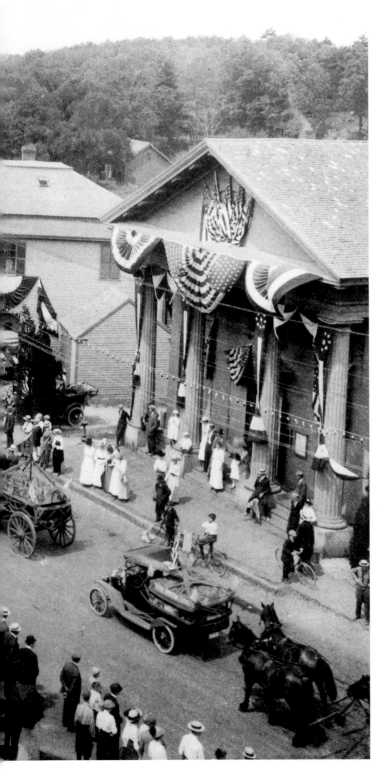

The Bicentennial Committee recommended three days of events to celebrate the founding of the town as a separate community in 1713. The Sunday morning festivities began with a "union service" for all townspeople at the First Parish Church. Monday was "devoted to the pupils in the public schools," with formal student presentations in the morning and a historical pageant and parade in the afternoon. The parade wound through the center of town. Tuesday featured athletic events, major speeches, and music, followed by a band concert and fireworks in the evening. This photograph was taken from the Paul Revere belfry of the First Parish Church. In commemoration of the celebration, Horace Sears presented each household with a copy of the town history written by Colonel Daniel Lamson.

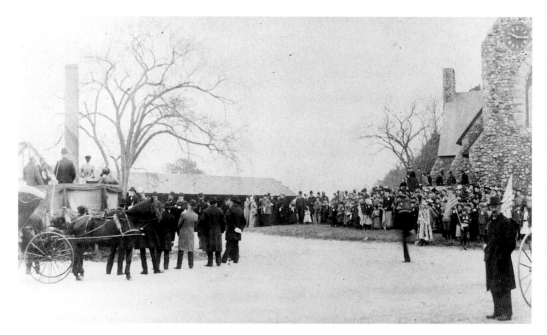

Town residents gathered to dedicate the "flag staff in the public square" in 1890. The flagpole was located in front of the First Parish Church, in the center of the intersection of Boston Post Road and School Street. The pole was erected with $250 voted in a town meeting and remained in this location until it was moved to the east of the new Town Hall in 1917.

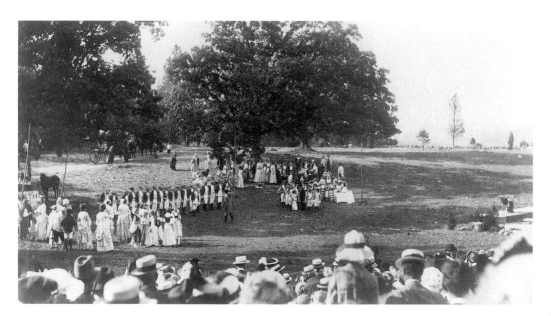

Robert Winsor offered the use of his field for staging the pageant, which included the re-enactment of the gathering of the Weston Light Infantry during the Revolution. Most Weston men who fought in April 1775 would have been members of the "train band." This band trained on the field in front of the First Parish meetinghouse in preparation for any eventuality, whether it be conflict with the French or the Native Americans.

Right: A high point of the day was the re-enactment of the arrival of the Vikings by longboat. John Paine built this ship, which was rowed smartly across Winsor's pond, to the delight of the 2,500 people present. Vikings met Native Americans in a ceremony marking the beginning of Weston. Whether or not Viking explorers ever touched Weston in their travels continues to spark debate among people interested in local history.

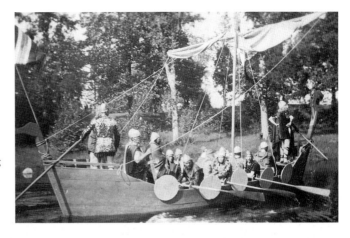

Below, left: Colonial dress was the rule for most of the 400 participants in the pageant. Here, R. Clark dresses as Reverend S. Woodward, who went with the train band on April 19, 1775. Reverend Woodward was called to First Parish in 1751. He read the Declaration of Independence at a service on September 8, 1776. Woodward served the congregation, "beloved by his people," until his death in 1782.

Below, right: The Norsemen's Tower, which overlooks the Charles River off Norumbega Road, continues to stimulate interest in the possibility of Viking exploration. Harvard Professor Eben Norton Horsford believed that Norsemen built a city on this site in the late 10th century, and he paid to erect the tower in 1889. Were the remains below the tower a city or an early stone raceway to channel water from Stony Brook to a mill?

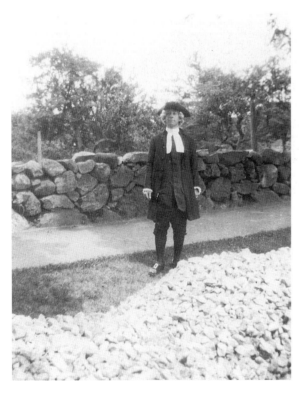

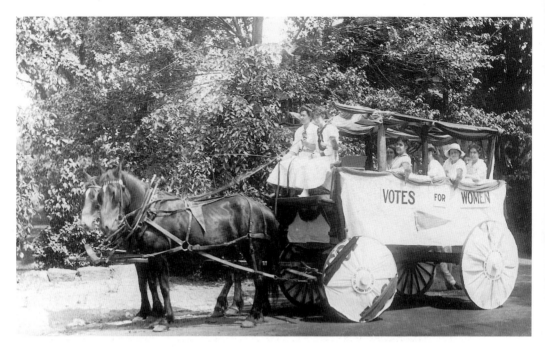

Some Weston women supported the suffrage movement. When women voted in school committee elections, the Waltham Free Press reported "no problems at the first election." Twenty-five years later, one woman was listed as a voter in the 1900 census. The float sent the message on its wheel: "Politics are rotten. Let the Women Vote." The Weston League of Women Voters continues to develop information and analysis of important issues.

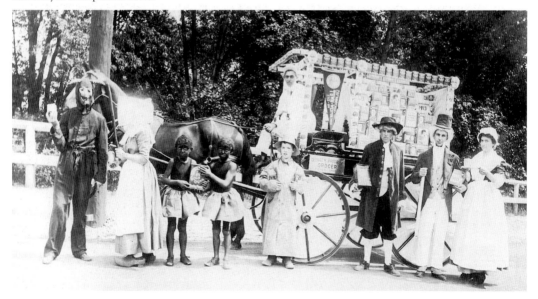

George Broderick Jr., owner of the general store at Kendal Green, dressed the characters on his float to advertise popular products, among them the Gold Dust Twins scouring powder, the gentlemen of Quaker Oats, and the lady serving Swiss Miss Cocoa. Merchants chose to highlight the popular products one could buy at their stores because there were few ways to advertise.

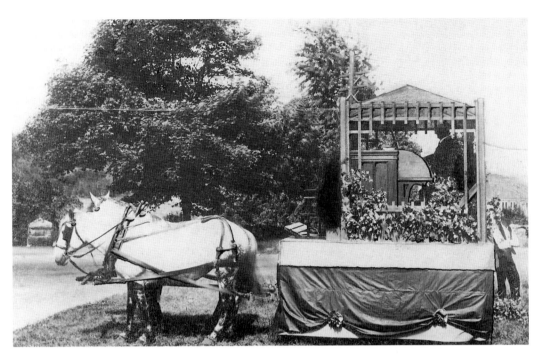

The best floats in the parade received prizes. The silver cup went to the Hastings Organ Company float, consisting of two wagons connected by an electrical cable; the organist and a keyboard were on the first float, while the pipes were on the second float. Religious and patriotic songs along with folk songs were played as the two wagons traveled the parade route.

Mr. Cutting entered this "Cutting's Store" wagon in the parade. Notice that Kellogg's Toasted Corn Flakes is the product featured on the side of the wagon. Corn flakes were a relatively new and profitable product, developed as a health food in Michigan by William H. Kellogg in the 1880s. The numerous American flags displayed on Mr. Cutting's float reflect the patriotic feeling of the period.

The Boy Scout Fife and Drum Corps provided music to keep the parade marchers in step. The Waltham Watch Company Band, the finest in the area, played for the parade, the band concerts, and the dancing under the "Big Tent" on the school grounds, which were an important part of the celebration. The formal program featured both vocal and instrumental music.

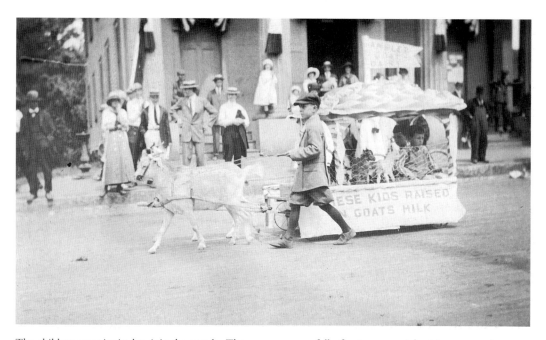

The children were invited to join the parade. These young men, full of entrepreneurial spirit, promoted the milk produced by the goats on their farm, the Ambler Goat Dairy. Note the kids fenced inside the float. These young goats must have been among the most active members of the parade.

The parade offered the opportunity for a resident to display his favorite horse and carriage. This unknown driver has a beautiful wicker carriage, complete with lanterns on each side for night driving. Behind the young man stands an automobile parked for the day. By 1913, automobiles outnumbered horses in town, with many townspeople owning both.

On the lighter side, this young clown entertained the crowds gathered along the parade route. Weston parades encourage participation by as many townspeople as possible. For the 275th anniversary of the town, the Class of 2000, then in kindergarten, marched along with floats from each of the schools depicting "old-time school days."

George Washington's visit to Weston was a favorite topic for town celebrations. Here Laurance H. Hart, as Washington, speaks to the citizens of Weston in 1932. The town was firmly in support of the Patriot cause, and Washington was the leader whose military heroism and responsible statesmanship appealed to Weston voters. Weston celebrated the Massachusetts Bicentennial by holding exercises in front of the Fiske Law Office.

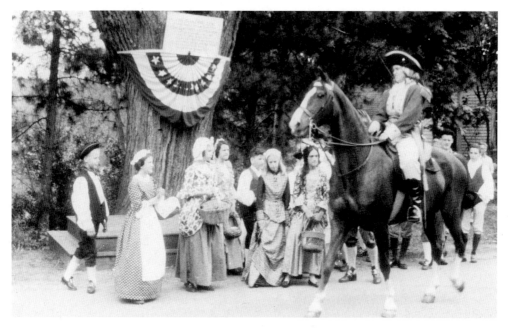

Pat Amadon took the role of George Washington during the 1963 commemoration of the 250th anniversary of the town. She has stopped in front of the Burgoyne Elm, where General Burgoyne's men camped as they were on their way to Winter Hill, Somerville, to be imprisoned. They had been captured at the Battle of Saratoga in 1777.